POSTCARD HISTORY SERIES

Hudson-Fulton Celebration of 1909

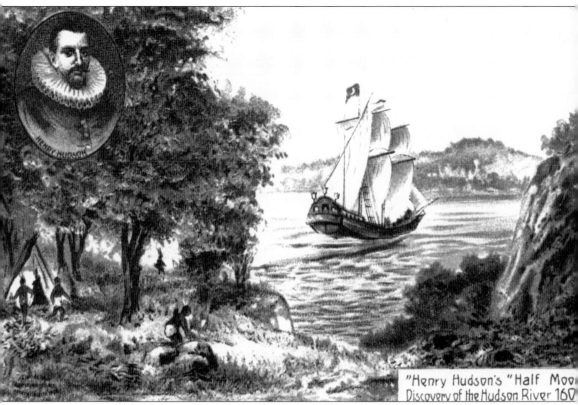

"Henry Hudson's "Half Moon
Discovery of the Hudson River 160

DISCOVERY OF THE HUDSON RIVER. Highly embossed, this popular set was widely reproduced even though copyrighted by the renowned publisher Joseph Koehler. The postcard series was a popular method used to sell cards at this height of the penny postcard era. Cards were used as a 20th-century blog of daily activities. Stores were stocked full of cards that ranged from views to greetings and artistic to humorous. (Joseph Koehler; author's collection.)

On the front cover: **THE HUMAN FLAG COMPOSED OF 2,500 ALBANY SCHOOLCHILDREN.** Across the entire state, young and old joined the Hudson-Fulton Celebration of 1909. Friday, October 8, 1909, was Albany's day that included a 100-gun salute on arrival of the *Clermont* and *Half Moon*, a grand processional of dignitaries, historical and naval parades, and fireworks. (Beach; author's collection.)

On the back cover: **REAL PHOTOGRAPH OF THE FLOAT ERIE CANAL BOAT.** This moment in time captures actors on floats lining up a yacht club for the historical pageant on Tuesday, September 28, 1909. In the foreground, dashing couples pose on the parade's 48th float, the Erie Canal Boat. Behind float 48, may be seen float 40, the Nathan Hale Float, with a uniformed officer at his tent. To the right, the Reception of Lafayette is the 47th float with its twin flags of friendship for France and America. (Porter Photograph; author's collection.)

POSTCARD HISTORY SERIES

Hudson-Fulton Celebration of 1909

Edward F. Levine
Foreword by Roger Panetta

ARCADIA
PUBLISHING

Published by Arcadia Publishing
Charleston SC, Chicago IL, Portsmouth NH, San Francisco CA

Printed in the United States of America

Library of Congress Catalog Card Number: 2008929024

For all general information contact Arcadia Publishing at:
Telephone 843-853-2070
Fax 843-853-0044
E-mail sales@arcadiapublishing.com
For customer service and orders:
Toll-Free 1-888-313-2665

Visit us on the Internet at www.arcadiapublishing.com

*To my family, thanks for your patience and understanding,
encouragement and participation, and love.*

CONTENTS

FOREWORD

When Edward Levine was six growing up in a family of collectors and inspired by his parents' example, he began buying postcards. Like many collectors, Levine rooted his work in a place known well, New York, a frequent vacation destination from his childhood home near Washington, D.C. His collection grew into 100,000 postcards and, eager to establish a foothold in a competitive and costly world of collectors, he began to focus on the 1909 Hudson-Fulton Celebration. This located him in a familiar geography and imposed on his collection the discipline of a subject, a classification system or taxonomy. He discerned the differences among images, subject matter, color, and design and identified the producers of valued sets of postcards. Aesthetics drew him to certain kinds of cards; however, this list of personal favorites could not distract him from his main task of completing the circle, bringing order to a mass of material, and organizing a collection recognized as definitive and of great importance to scholars.

Levine talks of his personal connection to the Hudson-Fulton cards, the interaction of the visual and narrative elements of the card with his aesthetic sensibility, the history gleaned from their captions and the way in which they encapsulated " a moment in time," reminding us that postcards do indeed capture such moments. We can see how his deep and abiding interest serves as an inspiration. He shares with other collectors an emotional response to the card's sensory complexity.

Levine's collection, and this volume in particular, is at the matrix of several interconnected themes. This timely publication will inevitably join the list of required readings for the 2009 Hudson-Fulton-Champlain Quadricentennial event and will serve as one of the primary documents in helping us understand 1909 and influencing our view of the contemporary celebration. In organizing the collection and authoring this publication, Levine also reconnects us to the events of those historic 17 days and draws us back to a time when postcard production, purchases, and collecting were at their high point; some called it a worldwide mania, and others have described it as the golden age (1895 to 1915) during which time 200–300 billion postcards were sold. Thus the intersection of the zenith of postcard fever, a sign of the emerging middle-class consumer culture, with the 1909 Hudson-Fulton Celebration was a dynamic conjunction of forces. At the same time a new postcard collecting vogue spread across the western world, and men who displaced early pioneer women collectors promised a more systematic and organized approach. Now the producers, consumers, and collectors, a trinity of shared interests, fed off each other and joined together to preserve for us a rich visual legacy, one we have begun to more fully appreciate.

Postcards and postcard collections, as artifacts of mass culture, were marginalized by scholars, who took the postcard's machine production, commercial design, low cost, and casual use as sure signs of its dubious qualification as a historic document. This uncertainty as to their scholarly credentials was reified by the lack of extended text and the "flip" nature of the written comments. In place of the detailed and carefully constructed prose of the 19th-century letter writers, here

we have the shorthand of the text message raising questions about the legitimacy of this new form of communication and its intellectual standing in the body of historical sources.

Salman Rushdie has suggested that postcards are the "souls of things." We have come to appreciate the layers of meaning attached to postcards, and if we want to understand their significance we must start at the moment of purchase, an action informed by many possible motives. As middle-class travel became more commonplace, the connection between tourism and postcards became an intimate one; the need for a souvenir acquired an urgency. The desire to appropriate a part of the experience was an impulse stimulated by the emerging consumer culture and led the traveler to purchase a card or a series of cards.

While we might assume that the next step entailed the writing of a short message and mailing the card to family or friend, in only half the cases were postcards scripted, indicating that many purchases were made for albums and collections. Researchers have bemoaned the terse messaging of most postcards that were actually sent, yet they served as a social glue, connecting individuals already part of a network of communication in a brief but efficient manner. Postcards were also gifts and objects of exchange, their purchase commissioned by collector friends or by family members hoping to expand their album or trade for more desirable cards with members of the burgeoning postcard clubs.

The souvenir postcards and the albums they filled helped the public bring order to a rapidly changing and shrinking world. They served as mnemonic devices, catalysts for memory, validating the experience of the traveler. The postcard constituted a world in miniature in which the old and new could be integrated into a unified and binding vision of place. Postcards looked to the past, celebrated the present, and embraced the future. This combination of boosterism and progressive optimism reassured the citizen collector and consumer.

The theme of nationalism permeates postcard imagery. Postcards presented American tourists and international travelers with the visual language of empire and validated a country's imperial aspirations and worldly status. They documented heroism in war, skyline architecture, urban growth, topographical views, picturesque scenery, technological progress, and a prosperous citizenry. Postcards expressed in small the cultural values and political beliefs of a country.

International fairs and expositions were prime subjects for postcard production. Their short duration made the postcard purchase an absolute requirement. They attracted large numbers of travelers from widely dispersed geographies eager for souvenirs. These unique events contained all the prerequisites for postcard success, including new inventions, elaborate physical structures, exotic displays, and markers of national pride and imperial success. The World's Columbian Exposition, held in Chicago in 1893, established the close relationship among such celebratory events, the public, and the postcard.

It is not surprising that the 1909 Hudson-Fulton Celebration would be the perfect occasion for a postcard bonanza. Here we have an international event, hosted by a world metropolis, with a historic river as the theatrical backdrop—all prime elements in a visually rich and profitable postcard series. Levine provides us with our own souvenir album and the opportunity to create afresh our own memories of the event. He invites us to look carefully and scrutinize as closely as he has, in order to discern the entangled meanings of these objects.

What is being celebrated here? How do the postcards offer clues to the goals and aspirations of the organizers and the values and beliefs of the modern city and an ascendant country? Let us follow the practice of historians and use these cards as primary sources and write our own story of the 1909 Hudson-Fulton Celebration.

In drawing on the body of emerging scholarship, I depended especially on the work of Bjarne Rogan, Carole Scheffer, Naomi Schor, and Susan Stewart.

<div align="right">

Roger Panetta
Visiting professor of history at Fordham University
Curator of Fordham University Libraries' Hudson River Collection
Adjunct curator for history at the Hudson River Museum

</div>

INTRODUCTION

The dawn of the 19th century was an age of discovery and exploration. Popular expositions and fairs worldwide looked back at history and celebrated the day. Futuristic innovations were unveiled from the dramatic Eiffel Tower at the Universal Exhibition in 1889 to the ice-cream cone at the St. Louis world's fair in 1904.

Starting on September 25, 1909, a 15-day Hudson-Fulton Celebration took place throughout the state of New York. This international showcase commemorated the 300th anniversary of Henry Hudson's discovery and the 100th anniversary of Robert Fulton's innovative demonstration of steam-powered navigation.

These historical events anchored settlements along the Hudson River valley that have become the envy of the world. This rich land is a significant center of population and has witnessed many of the western hemisphere's pivotal events.

Looking back, this event celebrated two pivotal events from New York's history. Henry Hudson discovered New York on September 2, 1609. The English captain of the Dutch ship *Half Moon* dropped anchor in what is now New York Harbor. Hudson was working for the Dutch East India Company to find a sea route to the Far East through North America. He attempted sailing up the narrowing river that now bears his name. His discovery introduced Europeans to more northern, closer lands within America. A Dutch colony followed in just five years.

An inventor and artist, Robert Fulton (1765–1815) is best known for launching the first commercially successful steamboat. Fulton developed the first steam-powered vessel to travel the Hudson River. Its name was the *North River Steamboat of Clermont*, which was later shortened to *Clermont*. On August 9 and 10, 1807, taking just 30 hours, the *Clermont* travelled from New York City to Albany, far faster than a normal sailing ship. His invention furthered the area's ability to become the world's commercial centerpiece. The following year a canal was proposed to link Lake Erie to the Hudson River.

Clearly too, this celebration looked forward. According to the official program printed by Redfield Brothers for the Hudson-Fulton Celebration Commission, "a prize of $10,000 [was] offered by the New York World for the aeronaut who, in a mechanically propelled airship, sails over the course from New York to Albany traversed by Fulton's first steamboat." This early Pulitzer prize was not awarded, but Wilbur Wright demonstrated spectacular flights to a million viewers from Governor's Island, over the Hudson, and around the Statue of Liberty.

The celebration was recorded widely on postcards that were the rage of the early 20th century. These printed images displayed the festivities and pivotal events that elevated New York as the Empire State and New York City as the Metropolis of the New World. Its citizens and visitors were invited to public events free of charge. Participation was clearly very large throughout naval and historical parades, receptions and dedications, and illuminations and museum exhibitions.

The events were centered in New York City but took place along the Hudson River Valley from West Point to Newburgh and Poughkeepsie and all the way up to the capital in Albany.

The celebration promised education rather than bragging. It was just eight years after the Pan-American Exposition in 1901. That exposition saw a presidential assassination, a historical event of a magnitude that New York certainly sought not to repeat. Thus, this event saw a concentration on the adoration and demonstration of New York by and for its people and its visitors. An important distinction was the use of existing streets, buildings, and waterways as the main setting for the event's venues.

These images captured the region's decorations and advertising as well as its deep historical riches and military might. Some postcards were commercialized, showing the strong link between New York and its businessmen. Funding was targeted to benefit merchant and state alike.

Now let's step back a century and visit the history and innovations of that day. Dutch merchants first found and built this region, the English participated and grew it, and the melting pot that is the Americans have set it apart as a premier place. Discover your connection to the present-day greatness of New York. Follow the flotilla and parade from native lands, through the great city of Manhattan, and upstream along the Hudson River to wonderful and proud villages and cities that make up the river valley community. Here please find a celebration by and for the people, the masses, presented for your enjoyment.

All material is from the author's collection. The author acknowledges that caption material is drawn from the documents portrayed in the images. The document's publisher is listed where identifiable.

One

READYING HONORS FOR
HUDSON AND FULTON
NEW YORK STYLE

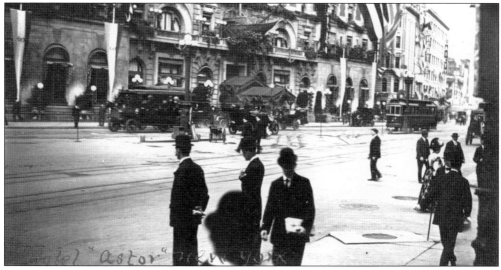

THE HOTEL ASTOR REAL PHOTOGRAPH. The center of the celebration, this hotel staged the official celebration commission banquet on September 29, 1909, seating approximately 2,000 guests. The premier location at Broadway and 44th Street was next to the Gaiety and Astor Theatre, seen in the background. The real estate was developed by the famous Astor family of New York City in 1904. John Jacob Astor was the first multimillionaire in America and made his fortune in the Revolutionary War era in fur trading. This location, now part of the infamous Times Square area, retains none of the buildings from this era. (Cyko.)

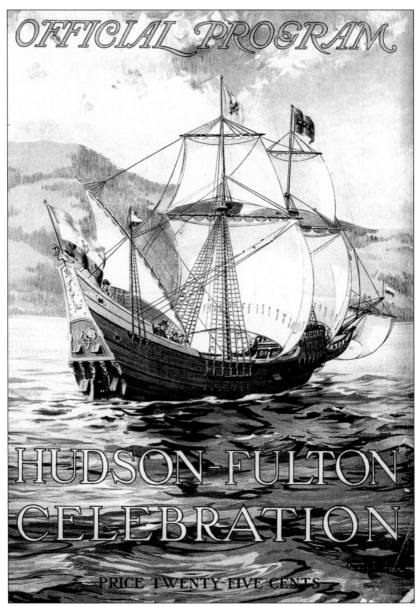

OFFICIAL PROGRAM. This publication was officially authorized by the Hudson–Fulton Celebration Commission. That commission planned and executed the events. It consisted of 750 citizens and was incorporated by chapter 325 of New York State law in 1906. The leader was Gen. Stewart Woodford, a prominent politician, including the Spanish ambassador role just prior to war with Spain in 1898. The commission included the leaders of all 47 of the state's cities and 38 villages along the Hudson River. Each of the five city boroughs organized citizen committees. Locally, New Jersey was strongly represented with 15 citizen representatives in the commission appointed by New York's governor Charles Evans Hughes upon nomination of New Jersey's governor Edward Casper Stokes. Each nation accredited by the United States was invited to send a delegation including diplomatic representatives from Washington. For the celebration, New York appropriated $475,000 and the City of New York $250,000. Additionally, nearly $500,000 was raised through private funding. (The Redfield Brothers Inc.)

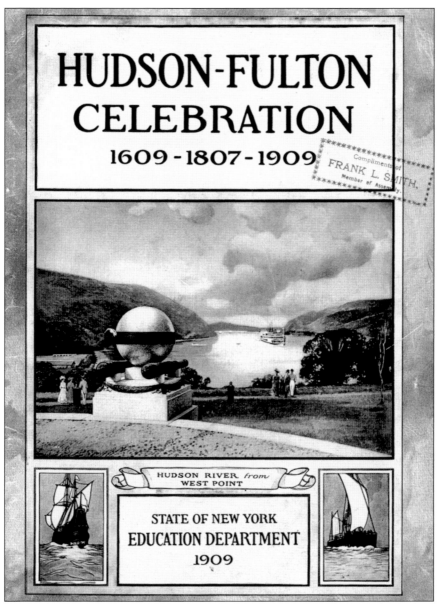

HUDSON-FULTON
CELEBRATION
1609 - 1807 - 1909

Compliments of
FRANK L. SMITH.
Member of Assembly.

HUDSON RIVER *from* WEST POINT

STATE OF NEW YORK
EDUCATION DEPARTMENT
1909

STATE OF NEW YORK EDUCATION DEPARTMENT BROCHURE. This document was compiled for use in schools throughout the state. It includes details of the state's history, representative artwork, photographs of historical places and people, lists of school observances, poems, subjects for debates, maps, charts, and suggestions for constructive exercises. Commemorative school activities were planned throughout the state to add emphasis to the event. Such special educational demonstrations included a Hudson-Fulton Week at Cornell University in Ithaca with a lecture on the geographical conceptions of America in 1608 by Prof. William Burr and an exhibition of maps in the university library. Ensuring wide involvement and excitement, the New York public schools held special exercises in each elementary school with grade-appropriate subjects like Native American games for kindergarten and how Robert Fulton opened the river to commerce for sixth graders. The brochure cover features an artistic rendering on the riverside lawn of West Point. (State of New York Education Department.)

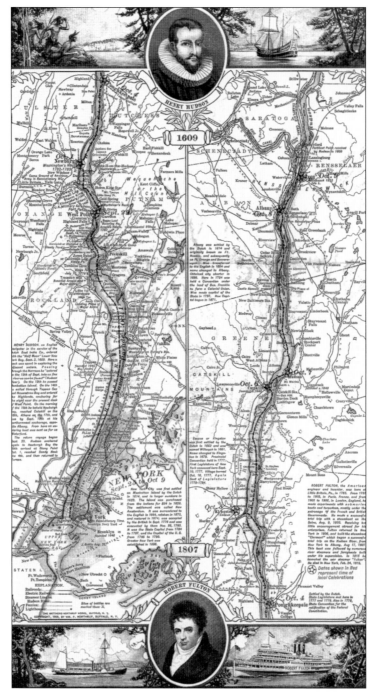

HUDSON–FULTON CELEBRATION MAP OF NEW YORK. From the education department's brochure inside cover, this handsome map features the celebration's key dates imprinted over their route along the Hudson River marked with red stars. Additionally, historical events in New York's history are described along with their locations. A marker across from the entrance to the Erie Canal highlights the farthest point that Henry Hudson reached on his journey upriver in 1609 near Waterford. (The Matthews-Northrup Works.)

HUDSON-FULTON CELEBRATION BROCHURE BACK COVER. The brochure's back cover features a copy of the event's official seal that was produced as a medal in conjunction with the American Numismatic Society. The representation was created by the artist Emil Fuchs. Henry Hudson and a group of six sailors watch ballast being thrown overboard while sailing upriver. The seal features historical navigational instruments, including an astrolabe and sextant. (State of New York Education Department.)

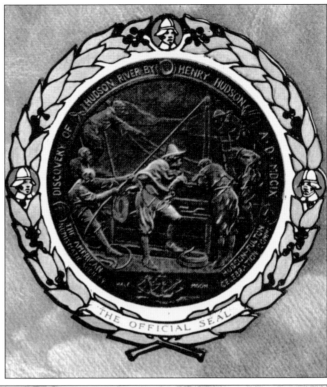

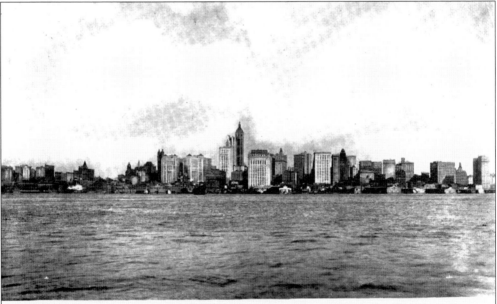

LOWER MANHATTAN TO-DAY

LOWER MANHATTAN TODAY. For a historical perspective, the card's reverse states how "Lower Manhattan in 1909 . . . looks today, 300 years after Hudson first entered the harbor. He would have been more startled by the great skyscrapers and strange sights than were the Indians who viewed for the first time the Half Moon and its crew." The Churchman postcard series superbly documented New York's history. (The Churchman Company and Irving Underhill.)

15

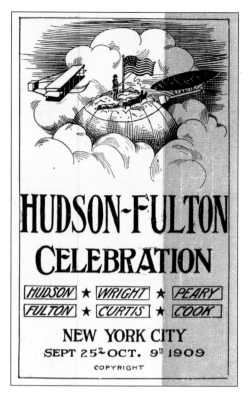

EVENT ADVERTISING FOR NEW YORK CITY.
Designed to advertise the parent homeland
Holland along with the event, the celebration's
official colors of broad pale blue and orange
stripes surround names meant to draw crowds.
The namesakes are proudly listed next to early
aviators Wilbur Wright and Glenn Curtis
and early arctic explorers Robert Peary and
Frederick Cook. For the monumental occasion
of flight, Wright paraded his plane as part
of the event. Curtis, an upstate motorcycle
manufacturer, had just demonstrated his flying
machine in Hammondsport. Concurrently,
Peary became the first to reach the North
Pole and is shown planting the American flag.
Cook, a New Yorker, was celebrated for his
earlier arctic claims.

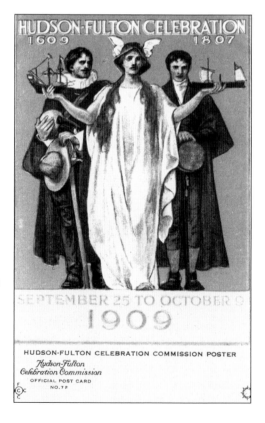

**NO. 72, THE OFFICIAL POSTER OF
THE HUDSON-FULTON CELEBRATION
COMMISSION.** The Redfield Brothers
produced a magnificent, official souvenir
series of postcards that featured the organizer's
seal and copyright as the "Authorized
Publishers." The classic, final No. 72
represented the Spirit of Progress, holding
in her hands models of the *Half Moon* and
Clermont, and supported on either side by
Henry Hudson and Robert Fulton. The
design is attributed to E. H. Blashfield.
(Redfield Brothers Inc.)

HOLLAND–AMERICA LINE POSTER. This wonderful poster displays the Holland-America's flagship cruise ship, the *Rotterdam*, in vignette surrounded by Hudson along with his *Half Moon*, a globe, and maps. This "Hudson Souvenir" honors "the Evolution in Transportation 1609–1909" and is proudly presented by the Holland-America line. Locally headquartered in Hoboken, New Jersey, the line carried the largest number of immigrants to America during a rapid period of New York's population growth.

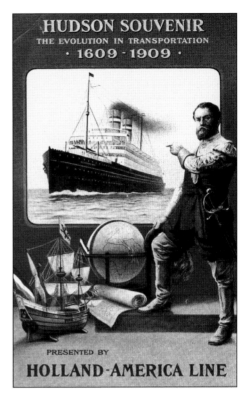

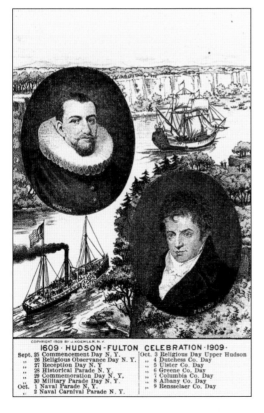

RIVER SCENE AND PROGRAM. This card has portraitures of Henry Hudson and Robert Fulton and their famed boats traversing the Hudson River with the Palisades featured as a bucolic backdrop above the celebration's schedule. The card appeals to citizens of upstate counties of Dutchess, Ulster, Greene, Columbia, and Rensselaer. The celebration commenced in Manhattan with a naval rendezvous and parade on Saturday, September 25, 1909. (Joseph Koehler Company.)

17

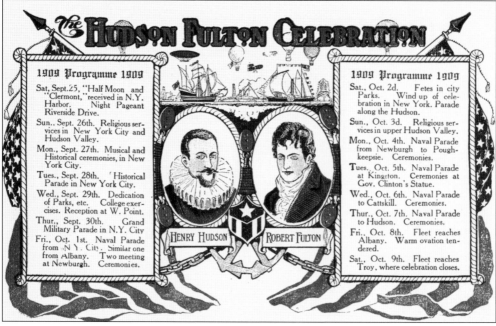

PROGRAMME. Henry Hudson with his ship the *Half Moon* and Robert Fulton with the steamboat *Clermont* present the celebration's schedule with a nautical theme and draping flags. Venues for the 15-day celebration events centered on water, but included religious services and military and historical parades. Events included 13 park dedications. (Frederick McAllister.)

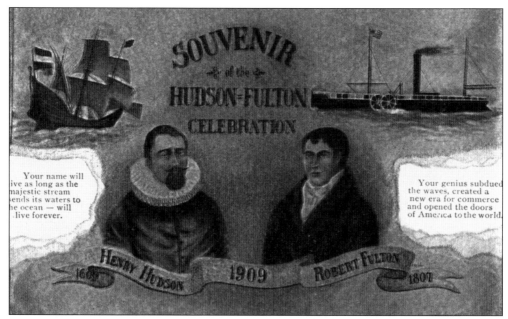

"YOUR NAME WILL LIVE LONG." Key celebration elements are combined with lofty quotes about Hudson's name living forever as the majestic river sends its water to the ocean. Although primitive in artistic style, grandiose statements about Fulton's genius subduing the waves and creating a new commercial era now seem comical in nature.

GREETINGS FROM NEW YORK. Postcards became wildly popular at the beginning of the 20th century following the discounting of the postage fee in half to 1¢ from the letter rate. This penny postcard features large letter greetings with a floral background and New York's official state seal, which contains the ladies Justice and Liberty, the Latin word *excelsior*, and Hudson and Fulton's sailing vessels. To sell more cards, this one was simply stamped with the event's designation. (A. S. Meeker.)

LARGE LETTER GREETINGS. Embossed and gilded in gold, gaudy features surround the celebration's namesakes with a huge, ruffled collar and fanciful goatee on Hudson. The state saluted the event with a chain of signal fires on mountaintops and eligible point from Staten Island to the head of navigation in Albany on October 9 complete with fireworks.

This is a small reproduction of the beautiful painting of

Henry Hudson's Half Moon

From the brush of WARREN SHEPPARD

The full reproduction measuring 10x15 will be sent postage FREE FOR ONE YEAR'S SUBSCRIPTION to *THE RUDDER*. $3 domestic, $4 foreign

THE RUDDER PUB. CO. 9 Murray St., New York, U. S. A.

HALF MOON ADVERTISEMENT FOR THE RUDDER. An artistic scene of the *Half Moon* cutting through the Atlantic advertises a special magazine subscription that offered a reproduction poster along with a year of the *Rudder.* This appeal to yachters furthered the extension of the celebration to the masses. (The Rudder Publishing Company.)

HENRY HUDSON, the English Navigator.

The "HALF MOON" in which Hudson discovered the River.

The Two Hudsons of the Hudson Crockery Co. who are constantly discovering new things in China for the beautifying of your table and your home. The Hudson Crockery Co. will be as pleased to have you visit and look as though you bought.

349 SOUTH SALINA ST., SYRACUSE, N. Y.

HUDSON CROCKERY COMPANY. A center of the Industrial Revolution, Syracuse became a leader in porcelain sales and production. Two Hudsons who owned this china company used an obvious connection to the celebration to advertise their company, featuring their photographs along with the English navigator.

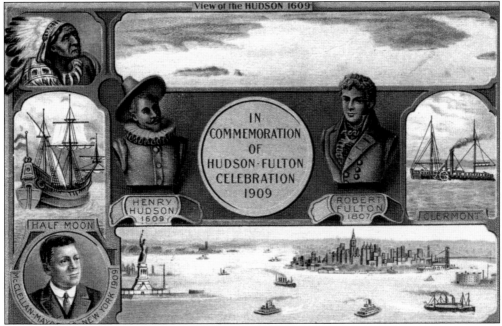

NEW YORK 1609 AND 1909 WITH MAYOR MCCLELLAN. A beautiful commemorative card features a handsome Native American, busts of Henry Hudson and Robert Fulton, and George Brinton McClellan Jr., who served as the Democratic mayor of New York City through the period of 1904 to 1909. This son of a Civil War general and presidential candidate was honored to oversee this grand event.

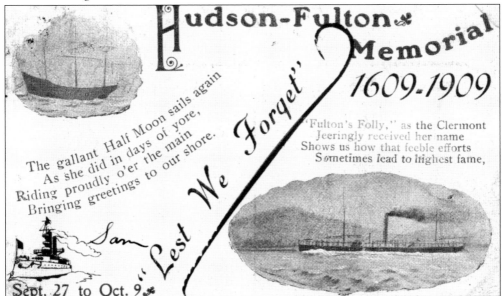

HUDSON FULTON MEMORIAL LEST WE FORGET. *Lest We Forget* is a phrase popularized by a Rudyard Kipling poem that pays homage to country. In particular, it was used to honor countrymen who served in the military and gave the ultimate sacrifice. This card was used by the sender in New Brighton, Staten Island, to offer a speedy recovery to the recipient. (Butler the Printer.)

***HALF MOON* WITH FLAG COLORS.** On the card's reverse, the sender wrote on October 5, 1909, that "Our whole city was hung with these color. We certainly have gone celebration crazy." Parade reviewing stands stood at the New York Public Library, for contributors on Central Park West, for the legislature on 59th Street between Seventh and Eight Avenue, and for aldermen on Madison Square. (Franz Huld Company.)

***CLERMONT* WITH FLAG COLORS.** The flag of the celebration proudly displayed the orange, white, and blue colors of Henry Hudson's sponsor, the United Provinces of the Netherlands. This miniseries features their ships, for which replicas were created, received with ceremony in harbor on September 25, 1909, and anchored in public view until the 29th. Throughout their travels, the ships were given military escort and full opportunity for public inspection. (Franz Huld Company.)

ORIGINAL HENRIK HUDSON FLAG. A waving celebration flag provides background for Henry Hudson's sail. The *A* on the flag represented the departure city of Amsterdam. *VOC*, abbreviated in Dutch, stood for the ship's financial backers, the United East India Company or Vereenigde Oost-Indische Compagnie. The flag displays the colors of the sail's home country, the Netherlands. (Anglo-American Post Card Company for M. Schwartz.)

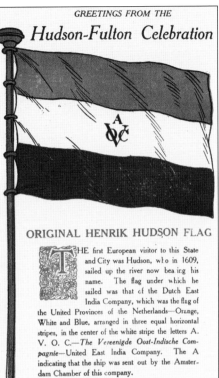

GREETINGS FROM THE

Hudson-Fulton Celebration

ORIGINAL HENRIK HUDSON FLAG

THE first European visitor to this State and City was Hudson, who in 1609, sailed up the river now bearing his name. The flag under which he sailed was that of the Dutch East India Company, which was the flag of the United Provinces of the Netherlands—Orange, White and Blue, arranged in three equal horizontal stripes, in the center of the white stripe the letters A. V. O. C.—*The Vereenigde Oost-Indische Compagnie*—United East India Company. The A indicating that the ship was sent out by the Amsterdam Chamber of this company.

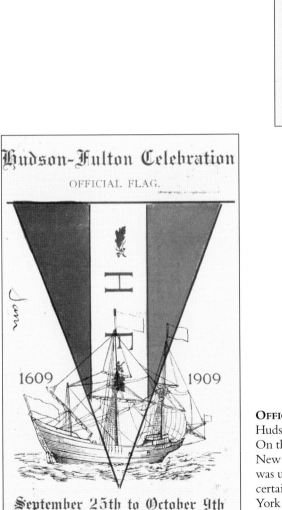

OFFICIAL FLAG. The celebration modified Hudson's original flag with a triangular shape. On the card's reverse, the sender wrote from New Brighton on September 29, 1909, that "I was up to see the parade yesterday and it was certainly . . . the finest celebration that New York has seen in many a long day. Italy made a grand showing and hundreds of other societies."

23

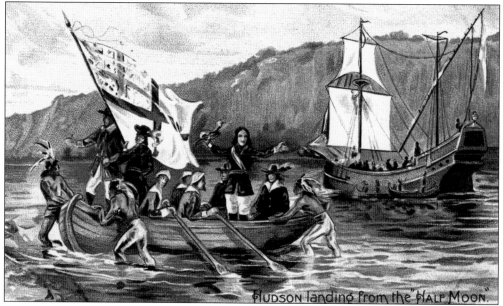

Tuck Hudson Landing from the *Half Moon*. This series came from the premier publisher of the postcard heyday period, Tuck. This London publisher was advertised as the "Art Publishers by Appointment to Their Majesties the King and Queen." The card set was printed in Saxony. This particular card features an imprinted advertising caption on the reverse for the Emery's Shoes and Hosiery on Pearl Street in Albany. Although never used, the card's imprint reads, "I found such beauties there today and reasonably priced." (Raphael Tuck and Sons.)

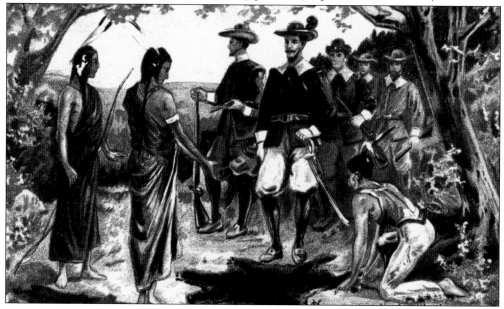

Tuck Hudson Trading with the Native Americans on Manhattan Island. While searching for a route to India and China, Henry Hudson found New York Harbor. Hudson's explorations in the valley led him to friendly natives who traded valuable furs in exchange for inexpensive trinkets. This card was compliments of the Fulton Trust Company of New York, which has since merged into what is now J.P. Morgan Chase. (Raphael Tuck and Sons.)

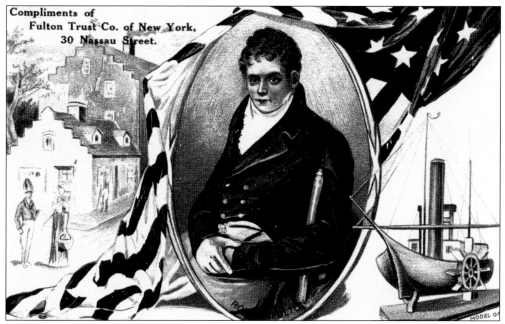

TUCK ROBERT FULTON. Featuring the pioneer of steam navigation handsomely inset against a model of his famous *Clermont*, a bucolic street scene offsets a draped U.S. flag. On the reverse, the card describes the *Clermont*'s measurements of 136 feet in length, 18 feet wide, 9 feet deep, and 160 tons. (Raphael Tuck and Sons.)

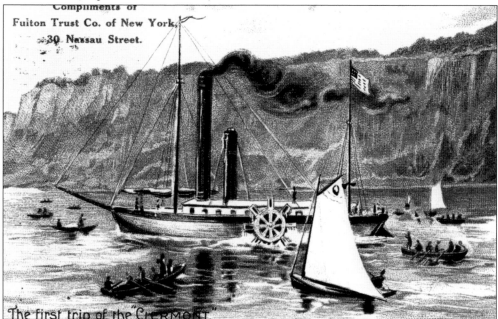

TUCK FIRST TRIP OF THE *CLERMONT*. The initial trip of this first commercially successful steamboat was made on August 11, 1807. Traveling 150 miles from New York City to Albany, the speed averaged five miles per hour. The fuel was fat pine that created a continuous trail of sparks and smoke. It was both primitive and a highly important demonstration of steam power still widely used today. (Raphael Tuck and Sons.)

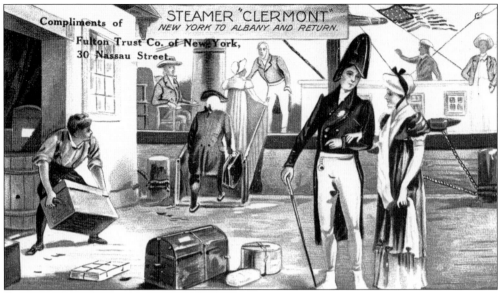

Tuck Dock Landing of the *Clermont*. Propelling commerce, the *Clermont* became a regular along the Hudson, traveling its length for passengers and freight. In the early 19th century, the fare was $7 for the 32-hour trip. Freight was carried at the rate of 3¢ per pound. By 1909, steamboats were three times the size, carried 2,000 passengers, and made the trip in 10 hours. (Raphael Tuck and Sons.)

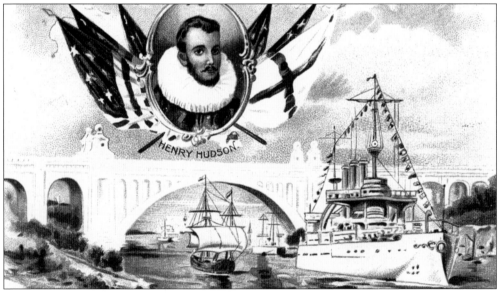

Tuck Hudson Memorial Bridge to Be Erected. The reverse caption reads, "a memorial bridge . . . to be erected at Spuyten Duyvil [Bronx], New York, crossing the Hudson River. It will be of re-enforced concrete, 2,870 feet long, 80 feet wide and 270 feet high, with a central span of 725 feet. The upper story is to have a roadway 50 feet wide and two walkways for pedestrians; four rapid transit tracks will be laid on the lower story. The bridge will cost $4,000,000." The bridge was planned by Prof. William Burr of Columbia University with Whitney Warren as architect. Plans for this longest masonry arch in the world included double-decker foot and rail traffic. (Raphael Tuck and Sons.)

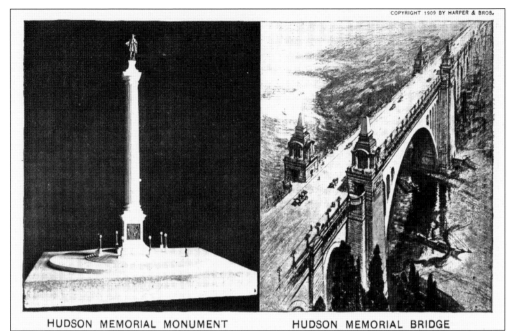

HUDSON MEMORIAL MONUMENT HUDSON MEMORIAL BRIDGE

HUDSON MEMORIAL MONUMENT AND BRIDGE. An additional memorial feature of a monument to Henry Hudson was introduced. The monument was designed by Karl Bitter and expected private funding of $100,000. The land at Spuyten Duyvil was donated and a Doric-style column erected by 1912. The statue of Hudson was not added and dedicated until 1938. The bridge was started in 1935 and completed in 1936. The second deck added the seventh traffic lane in 1938. Originally, the bridge was painted green; now it is blue. Over the Harlem River, the bridge enters the Henry Hudson Westside Parkway and is parallel to the Major Deegan, and labeled *New York 9A*. (The Churchman Company and Harper and Brothers.)

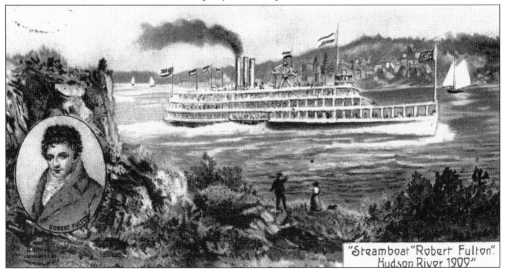

"Steamboat "Robert Fulton".
Hudson River 1909"

JOSEPH KOEHLER STEAMBOAT *ROBERT FULTON*. This new steamer the *Robert Fulton* was introduced in 1909 as part of the Hudson River Day Line. Continuing the dependable passage from New York to Albany, the line offered reasonable prices, comfort, and spacious accommodations. By this time, the speed had increased to 15 miles per hour. (Joseph Koehler.)

DUTCHMAN AND NEW YORK SKYLINE. A classic connection of the historical events honored by the celebration with the modern era features a handsome Dutchman dressed in the founder's period clothing proudly holding a 1909 warship while pointing to that day's New York City skyline. Robert Fulton's steamboat *Clermont* and the seal of the great state of New York complete the design. (H M Rose.)

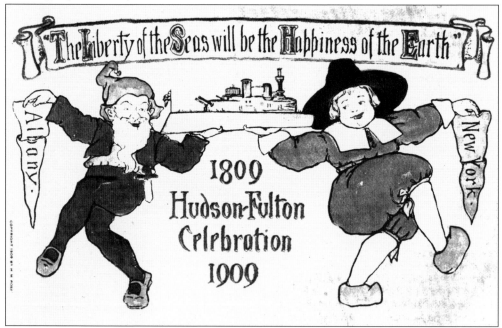

"THE LIBERTY OF THE SEAS WILL BE THE HAPPINESS OF THE EARTH." Whimsical caricatures of a blond, cherubic Dutch boy proudly waving a New York pennant and of the diminutive, elder Rip Van Winkle with an Albany pennant pay homage to the sea, the Dutch founders, and the New York author Washington Irving. The card's warship touts strength through military prowess. (H. M. Rose.)

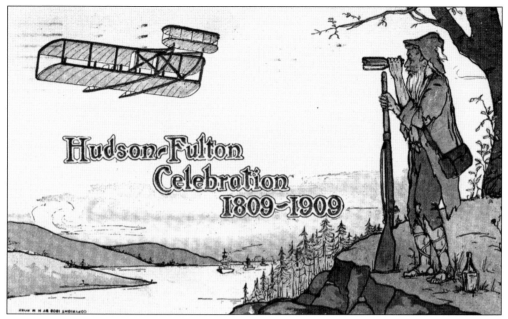

OLD MAN AND AIRPLANE. For the celebration, aviators Glenn Curtis and Wilbur Wright were paid to make aeronautic demonstrations. That sight drew a great deal of excitement on the second day of the celebration, Monday, September 27, 1909. Here an old man from the hills looks through his whiskey bottle for the source of the flying machine. (H. M. Rose.)

OLD MAN AND DIRIGIBLE. Balloon transportation had become more viable ahead of airplanes. By 1909, the Zeppelin Company had established itself and conducted commercial traffic. The enormous design lent itself to many card images of that time but proved less efficient in the long run. Advertising the celebration, the vehicle display is used like blimps today. (H. M. Rose.)

29

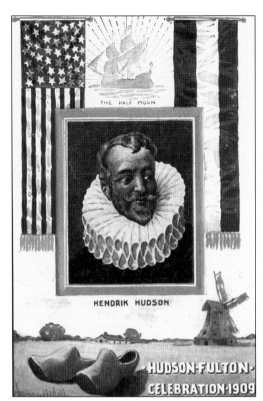

BERNHARDT WALL, HENDRIK HUDSON. This series of six cards was drawn by Bernhardt Wall, a prominent print artist from that era. Born in Buffalo and living in New York City, he produced thousands of images for postcards. Classic Dutch and American symbols are brought together in this striking image. (Valentine and Sons Publishing Company.)

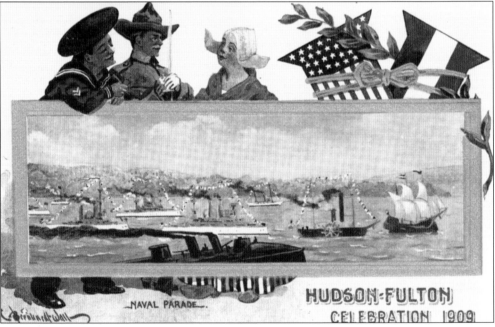

BERNHARDT WALL, NAVAL PARADE. Military recruits in their finest uniforms look after a Dutch girl in clogs and the traditional flyaway hat. The U.S. and Dutch flag colors stand together, tightly knotted in a bow. Theodore Roosevelt, the second American president of Dutch origin, served from 1901 to 1909. The naval parade takes center stage. (Valentine and Sons Publishing Company.)

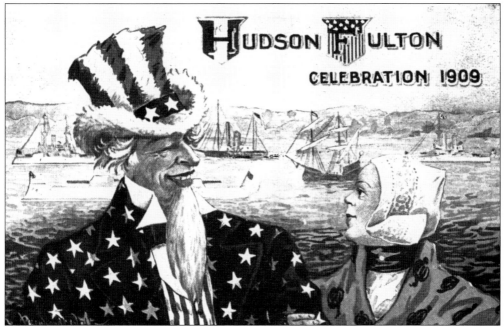

BERNHARDT WALL, UNCLE SAM AND DUTCH GIRL. This classic scene in Americana depicts Uncle Sam dressed in stars and strips with a fur top hat of red and white strips. The patriot is hand-in-hand with an admiring Dutch girl draped in her native blue and orange. The two stand in front of the naval parade. (Valentine and Sons Publishing Company.)

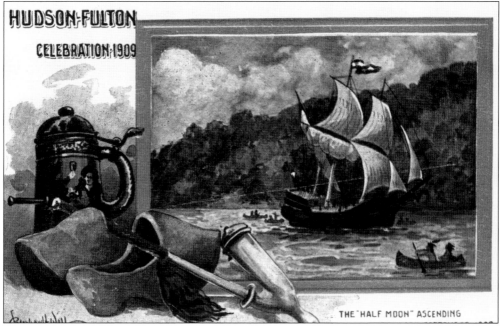

BERNHARDT WALL, *HALF MOON* ASCENDING THE HUDSON. This beautifully illustrated series by a much sought-after, master postcard artist is available either embossed or flat. The embossed series was printed in Great Britain, the flat in New York. Classic Dutch symbols of clog, mug, and pipe adorn the picture of the *Half Moon*. (Valentine and Sons Publishing Company.)

BERNHARDT WALL, ROBERT FULTON.
Robert Fulton is inset above his smoking *Clermont*. Fulton sits under the classic Greek laurel wreath adding prominence to his name. Wall's specialties were comical subjects and greeting cards that captured the day's culture with cherubic faces. (Valentine and Sons Publishing Company.)

BERNHARDT WALL, FULTON IN HIS STUDIO.
A wigged Fulton works hard in his studio with a white cat at his feet. This multitalented individual is featured with his model of the *Clermont* and painting as works in progress. Fulton studied art under Benjamin West. Fulton later produced other lesser-known inventions, including a submarine and a torpedo. (Valentine and Sons Publishing Company.)

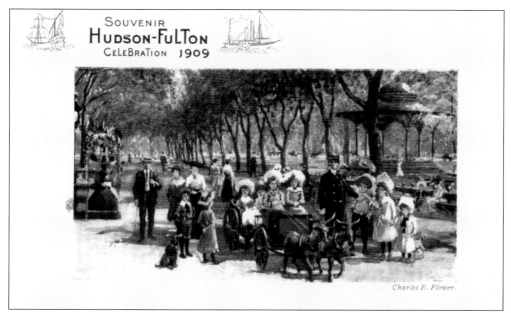

SOUVENIR CARD OF THE MALL IN CENTRAL PARK. This "Oilette" series postcard by artist Charles E. Flower features the mall in Central Park. That area is a level stretch of high ground about one third of a mile long. Stately elms and benches are set in rows along the sides. Concerts were held at the northern music stand twice a week in the summer, attracting great crowds. The card was overprinted for the celebration. (Raphael Tuck and Sons.)

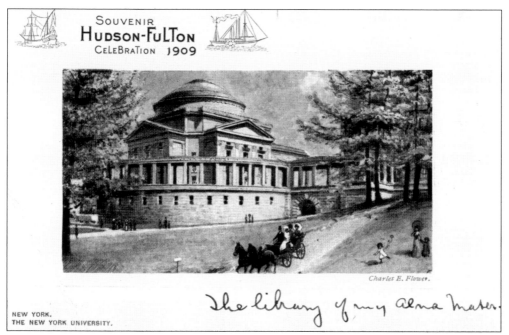

SOUVENIR CARD OF NEW YORK UNIVERSITY. An additional "Oilette" series card by artist Flower was overprinted for the celebration and features the library of New York University. That building includes a hall of fame connecting the halls of philosophy and languages. Within, a colonnade of 150 panels bears the names of great Americans. (Raphael Tuck and Sons.)

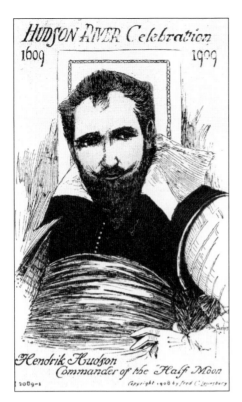

FRED C. LOUNSBURY, HENDRIK HUDSON, COMMANDER OF THE *HALF MOON*. Another blockbuster postcard producer, Fred C. Lounsbury produced this four-card set. Lounsbury was known for extremely high-quality greeting cards. This richly colored and highly embossed series with signature artist C. Beecher adds further credence to the importance of the celebration. The postcard series was created to sell cards. This card set was never mailed, remains in mint condition, and has been left intact for its 100-year life. (Fred C. Lounsbury.)

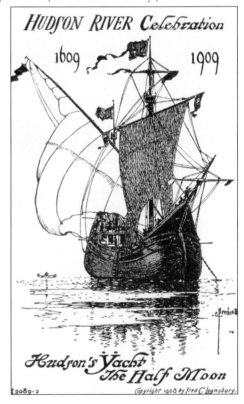

FRED C. LOUNSBURY, ROBERT FULTON, BUILDER OF THE *CLERMONT*. Here Fulton is painted in classic a pose. The likeness probably copies his study painted by Benjamin West, an American painter famed in London at the dawn of the 19th century. Fulton apprenticed in West's London studio. (Fred C. Lounsbury.)

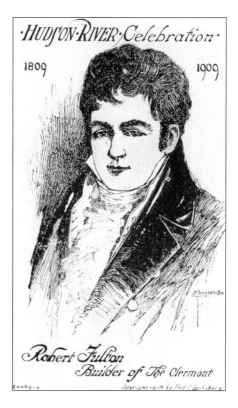

FRED C. LOUNSBURY, *CLERMONT*, FULTON'S STEAMBOAT. Claims to the first commercial steamship can certainly be disproved. Fulton claimed to have the first successful steamship with paddle design with an extended financial success. His ship was neither the first powered by steam nor the first steamer to be operated in scheduled service. (Fred C. Lounsbury.)

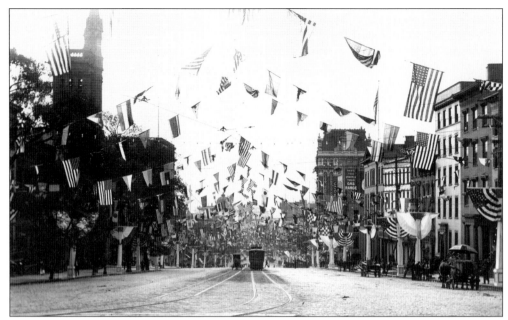

FLAGS ON THE AVENUE. New York City was dressed up. The streets shined with thousands of flags waving like jewels. Across each building along the wide avenue and up the light posts, the city was studded with drapes of colors. This real–photo postcard shows that New York was in an excited state of readiness for its celebration. (Cyko.)

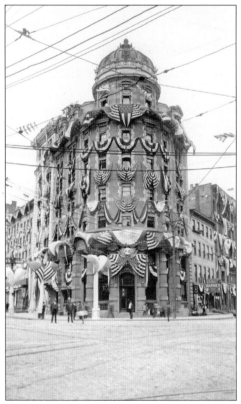

REAL PHOTOGRAPH OF ROUNDED STREET CORNER. Manhattan was draped in flags. This classic Beaux–Arts, rounded corner building was sumptuous in its grandeur. Two policemen pose in front. Next door, even the Warner Pharmacy drapes its front windows in flags. Massive electrical wires are seen overhead supporting the street-level trolley car system. (Cyko.)

REAL PHOTOGRAPH OF SAVINGS BANK.
This scene bedecked with flags for the
celebration features the buildings for a
book publisher, Joseph McDonough, a
savings bank, and a theater. This original
photograph features the Empire Burlesque
Theater, located at 1430 Broadway just south
of Times Square. A sidewalk poster offers
shows to ladies for just 10¢. A couple pushes
a wheelchair onto the crosswalk in the
lower left-hand corner. The card documents
Broadway as a 1909 fashion and theatrical
showplace. (Cyko.)

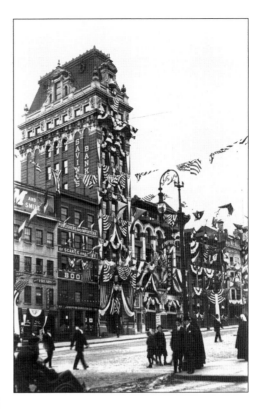

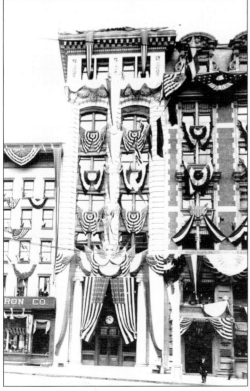

**REAL PHOTOGRAPH OF MANHATTAN
ROW.** Magnificent decorations lined the
avenues. This luxurious neoclassical building
in the center with Ionic columns features
numerous advertisements for stocks, bonds,
and other investment services imprinted
in the windows. Metal fittings can be seen
on display in the store windows on the
left. A dashing proprietor stands in front
of the building on the right, while a boy
casually leans against the building reading a
newspaper. (Cyko.)

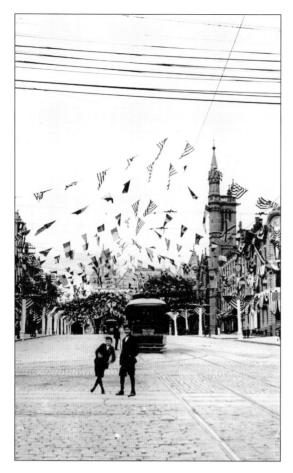

REAL PHOTOGRAPH OF BOYS AND TROLLEY. The late 1800s saw the development of electricity, and electronic trolley service soon followed. By 1904, Manhattan had elevated railway and subway service. Overhead power lines covered the sky but replaced street-level horsepower and related refuse. Two boys pose playfully in front of the trolley car. A classic Gothic tower may be seen rising among the flags of other buildings along the avenue. (Cyko.)

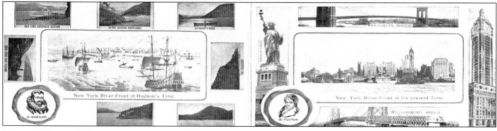

NEW YORK RIVERFRONT AT HENRY HUDSON'S TIME AND AT PRESENT. This double-sized folded postcard features an inset miniature of Henry Hudson and his fleet coming upon the native villages. Surrounding views are Down River, Sugar Loaf Mountain, the Palisades, Anthony's Nose, the Hudson Highlands, the day line *Hendrik Hudson*, and Fort Putnam. On the second half, the riverfront of 1909 is surrounded by Robert Fulton in miniature, the Statue of Liberty, the Brooklyn Bridge, the Singer Building, and the Williamsburg Bridge. The card has instructions on the reverse to "Write on the Back," to "Put Rubber-Band around folded Card," and to use "One Cent Postage to all Parts of the World." (Franz Huld Company.)

Two

THE NAVAL PARADE

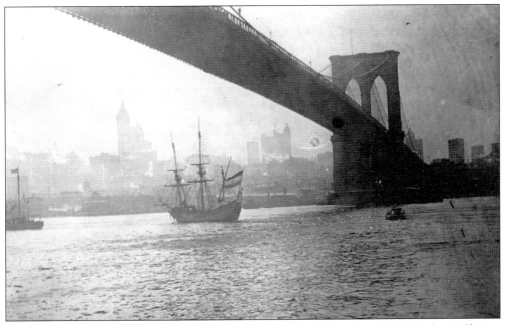

HALF MOON AT THE BROOKLYN BRIDGE. On Saturday, September 25, 1909, the *Half Moon* and *Clermont* were ceremoniously paraded through New York City's waterways. The Brooklyn Bridge's classic Gothic arch towers over the sail that was accompanied by naval militia and other vessels. Brooklyn established viewing stands on Shore Drive at Bay Ridge for 15,000. At 10:20 a.m., the escort squadron massed at Kill van Kull and proceeded on to Staten Island and Brooklyn for three hours of various borough festivities before starting up the Hudson River. (Cyko.)

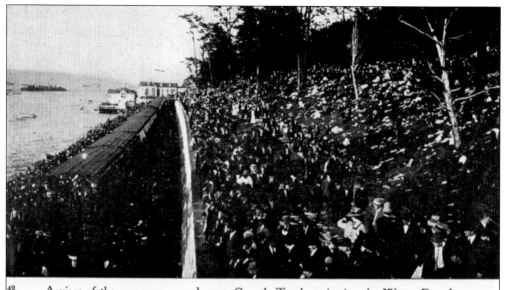

42 A view of the enormous crowds near Grant's Tomb reviewing the Water Parade
September 25th, 1909, "Hudson Fulton" Celebration

ENORMOUS CROWD NEAR GRANT'S TOMB. The escort squadron was received at the reviewing stands at Riverside Park by a mass of onlookers. The two key ships were officially received at 3:15 p.m. and anchored in public view for the next four days. Passing southward, the remaining flotilla was officially reviewed at 4:00 p.m. as the opening of Manhattan's portion of the celebration. (Empire P. and P. Company.)

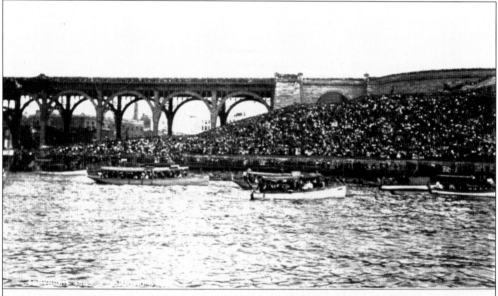

HUDSON-FULTON NAVAL PARADE, SEPT. 25th, 1909.
CROWD VIEWING PARADE FROM VIADUCT.

CROWD VIEWING PARADE FROM VIADUCT. At the foot of the elevated Manhattan Riverside Parkway extension of the West Side highway to Washington Heights, thousands gathered to watch the parade of torpedo boats, naval militia vessels, submarines, merchant fleet, and other watercraft. (Hippodrome Publishing Company and E. Tanenbaum.)

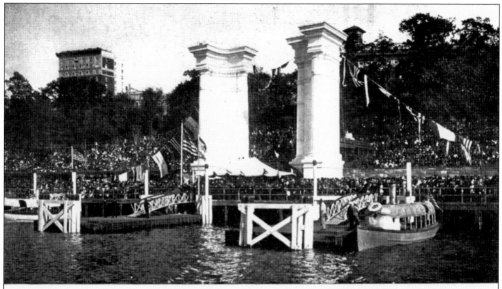

53 The Official Reviewing Stand at 110th Street and Riverside Drive, New York, of the Water Parade, September 25th, 1909, "Hudson-Fulton" Celebration.

THE OFFICIAL REVIEWING STAND. The merchant fleet headed up the Hudson River at 1:15 p.m. and joined the escort squadron of the *Half Moon* and *Clermont*. The squadron passed the war vessels and was received at the official reviewing stand at 110th Street and Riverside Drive at 3:30 p.m. A half hour later, the merchant fleet passed the stand. (Empire P. and P. Company.)

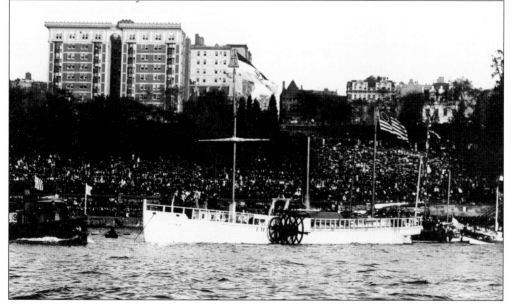

CLERMONT AT DOCK. A representative of the Fulton family was designated as honorary commander of the replica *Clermont*. Foreign vessels were officially recognized from the Netherlands, Germany, Great Britain, France, Italy, Mexico, Cuba, Argentina, and Guatemala. The replica *Clermont* measured 150 feet long and 18 feet wide and was built by the celebration commission. Nearby Manhattan apartment buildings host a commanding view with draped flags and residents visible in the windows in these photographs. (Cyko.)

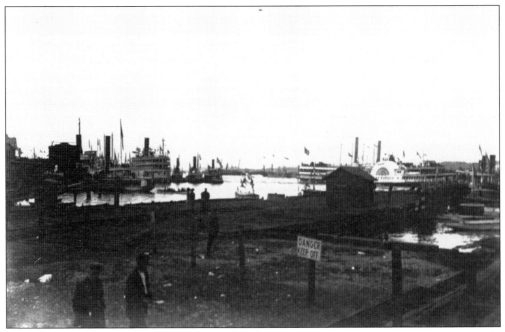

THE DOCKS AND THE PARADE. One can imagine so many vessels that one could seemingly walk across the river. Up the Hudson River, the great parade travelled. The *Half Moon* led, and she was manned by a Dutch crew in period costume under the command of Lt. Comm. W. Lam of the Royal Netherlands Navy impersonating Henry Hudson. She weighed 80 tons and measured 63 feet on the waterline. The vessel was presented as a gift of the Dutch to the celebration commission. (Newcomb Publishing Company.)

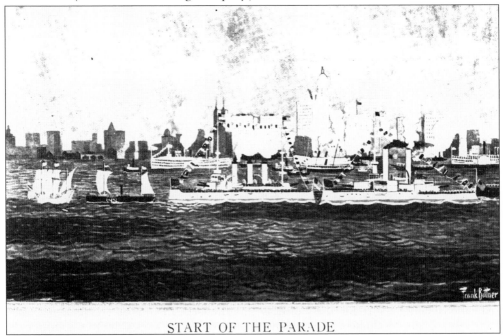

START OF THE PARADE

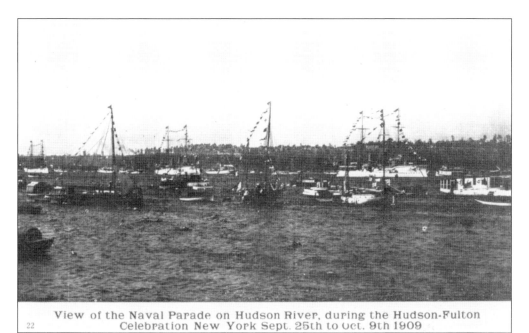

View of the Naval Parade on Hudson River, during the Hudson-Fulton
Celebration New York Sept. 25th to Oct. 9th 1909

VIEW OF THE PARADE. The U.S. contingent included 16 battleships, 3 armored cruisers, 3 scout cruisers, 12 torpedo boats, 4 submarines, 2 parent ships, a tender ship, 2 supply ships, a repair ship, a torpedo vessel, a tug, and 7 collier ships for carrying coal. (Empire P. and P. Company.)

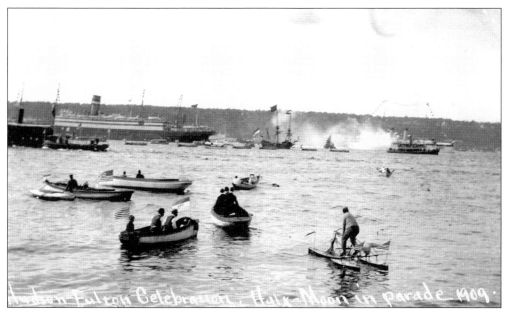

HALF MOON **IN PARADE.** The *Half Moon* is seen surrounded by its squadron of local, regional, and national police and public safety officials in steamboats, steam yachts, a motorboat, tugs, and steam lighters. Most interesting is the trimaran in the foreground with three wooden hulls supporting a single man navigating the river with a self-propelled gear engine. Something like a bicyclist on water, he sits high but lags behind the oared boats. (Azo.)

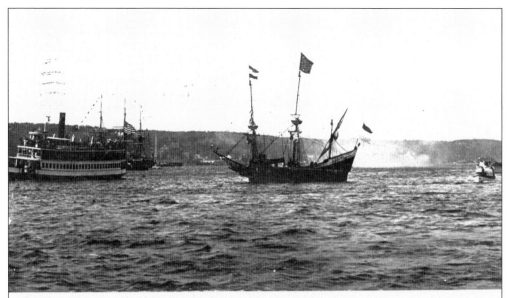

Arriving of the HALF MOON at the offical reviewing Stand 110th St. & Riverside
20 Drive, for the HUDSON-FULTON celebration N. Y. Sept. 25th to Oct. 9th 1909

ARRIVAL OF THE *HALF MOON*. Official guests were given public reception at Governors Island, which was the United States military headquarters. At Riverside and 110th Street, the official naval reception took place on the afternoon of September 25. The arrival of the *Half Moon* highlighted these events. (Empire P. and P. Company.)

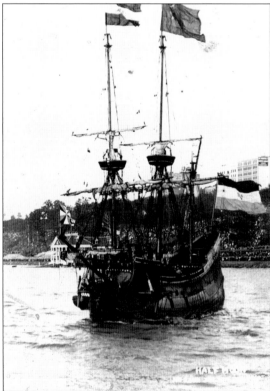

HALF MOON. Ship hands may be seen in authentic costume along the deck of the wooden vessel. The original Hudson flag may be seen proudly waving in the wind. The Netherlands was represented by this replica as well as HMS *Utrecht.* A new replica and flotilla is planned for 2009 under the auspices of the Hudson-Fulton-Champlain Quadricentennial Commission established in 2002 to plan the 400th anniversary celebrations with an additional honor to Samuel de Champlain, founder of the St. Lawrence River. (Cyko.)

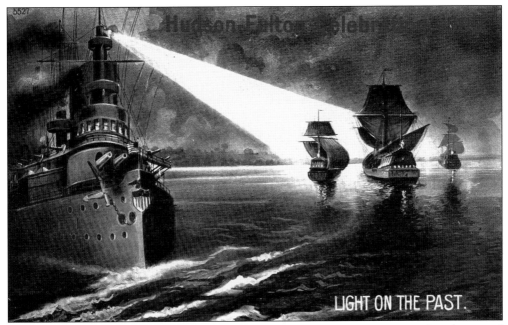

LIGHT ON THE PAST. A stylized scene highlights the power and importance of modern naval vessels and their historic source. Reminiscent more of the *Nina, Pinta,* and *Santa Maria,* this card was for sale at the celebration, a clear commercialization of popularized events. (A. C. Bosselman and Company.)

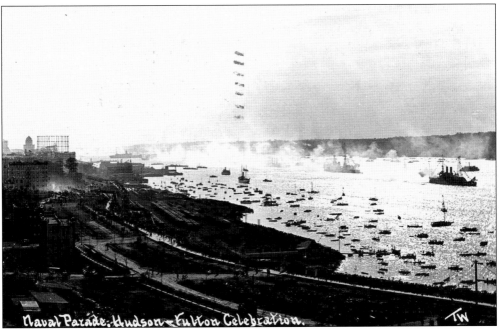

NAVAL PARADE. With a view toward Grant's Tomb, the massive parade and water gathering is seen in its glory. Masses of onlookers line the shoreside and roadways around a holding lot for railway and trolley cars. Steam rises up around the big vessels, obscuring some views across to the Palisades. (T. Wilkerson.)

45

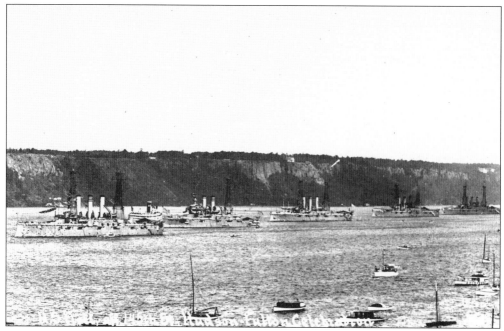

U.S. FLEET OFF 145TH STREET. The United States assembled 53 vessels under the command of Rear Adm. Seaton Schroeder, then commander of the Atlantic fleet. Foreign vessels numbered 19 with Germany and Great Britain each sending 4. Warships were docked between 44th Street and Spuyten Duyvil. (T. Wilkerson.)

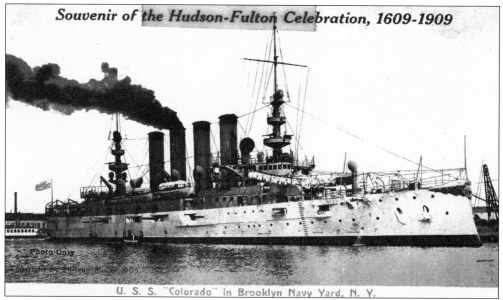

USS *COLORADO*. This armored cruiser ACR-7 was commissioned in 1903 and in the Far East during the celebration. The *Colorado* was renamed the *Pueblo* and served in World War I. The card was originally published in 1905 and printed as a celebration souvenir. (Enrique Miller photograph, American New Company.)

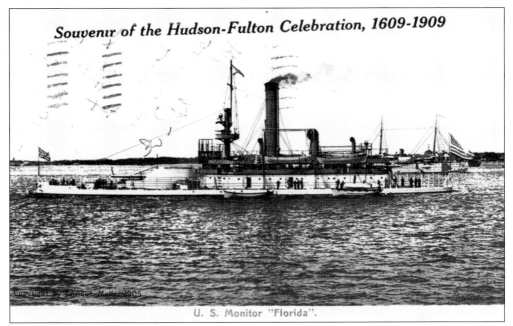

Souvenir of the Hudson-Fulton Celebration, 1609-1909

U. S. Monitor "Florida".

U.S. MONITOR *FLORIDA*. This monitor BM-9 was commissioned in 1901 and renamed the *Tallahassee* in 1908. She was likely in reserve during the celebration but returned to tender submarines during World War I. (Enrique Miller photograph, American New Company.)

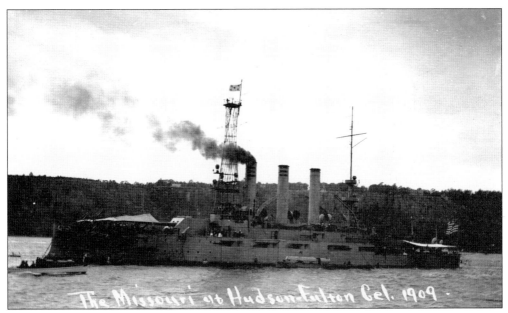

USS *MISSOURI*. This battleship BB-11 was commissioned in 1903 and served as part of the celebration festivities after having performed similar duties as part of the Jamestown Exposition of 1907. She performed dignitary duties prior to World War I and then served as a training ship during the war. (Azo.)

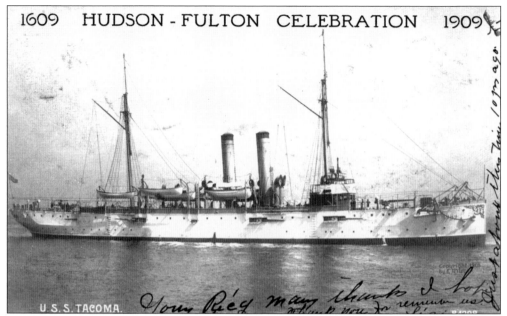

1609 HUDSON - FULTON CELEBRATION 1909

U.S.S. TACOMA.

USS TACOMA. The USS *Tacoma* is seen here in a real photograph dated 1905. The card was later retitled for the Hudson-Fulton Celebration. This cruiser was likely in Central America during the celebration, but had strong ties to New York, having carried Japanese diplomats to Theodore Roosevelt's house, Sagamore Hill. A meeting with Russian diplomats at Sagamore was a precursor to the armistice agreement ending the Russo-Japanese War in 1905. The back of this postcard is undivided. Until 1907, the reverse of a postcard was restricted exclusively for the stamp and address. (E. Muller photograph, Rotograph Company.)

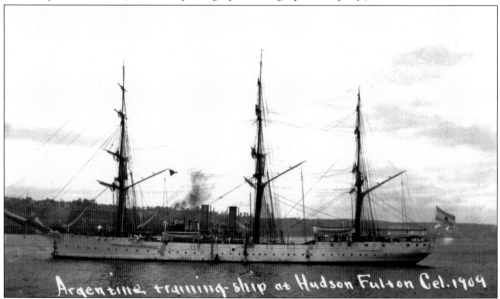

Argentine training ship at Hudson Fulton Cel. 1909

ARGENTINE PRESIDENTE SARMIENTO. Argentina sent a single warship to the celebration. The naval parade encircled the fleet of war vessels traveling up the Jersey shore and down Manhattan's shores passing the reviewing stands. Religious observances for Saturday worshippers were held throughout the city. (Azo.)

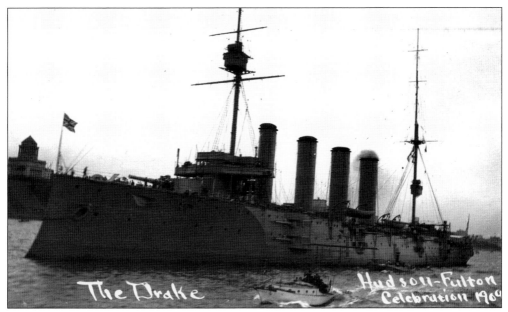

The Drake Hudson-Fulton Celebration 1909

HIS MAJESTY'S SHIPS. Under Edward XII, Great Britain sent four ships to the celebration under command of admiral of the fleet Sir Edward Hobart Seymour. The military level represented is equivalent to a five-star ranking, which Seymour held since 1905. Seymour served as commander in China during the Boxer Rebellion in 1897. These two armored cruisers both fought in World War I, although with different fates. The *Duke of Edinburgh* survived while the *Drake* was sunk off northern Ireland by a German U-boat. Her sister ship, the *Argyll*, sailed in the celebration and later wrecked in 1915. Grant's Tomb may be seen just off the bow of the *Drake*. (Azo.)

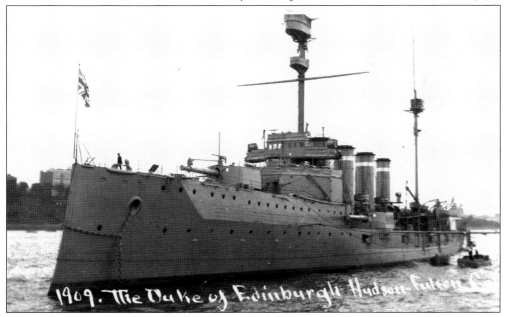

1909. The Duke of Edinburgh Hudson-Fulton C.

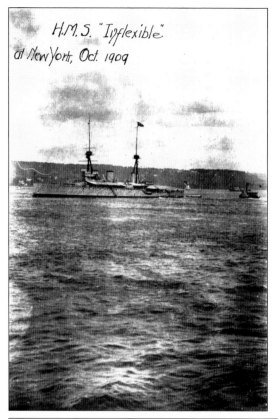

H.M.S. "Inflexible" at New York, Oct. 1909

HMS INFLEXIBLE AT THE CELEBRATION. This great battleship-cruiser was the largest warship built to date in 1909. She had higher speed than previous cruisers and survived battle in World War I. At the celebration, Adm. Edward Hobart Seymour flew his flag in command of the British battalion on the *Inflexible.* Second of three of a new giant for battle, she fought in the Mediterranean and Falklands during World War I and was scrapped by Germans in 1923. She weighed over 17,000 tons and was 530 feet long at the water. Her twin, polished gun turrets may be seen prominently on the foredeck. (Azo.)

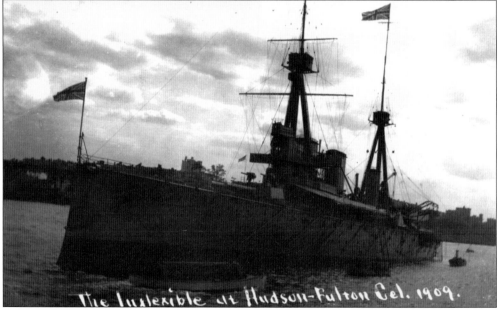

The Inflexible at Hudson-Fulton Cel. 1909.

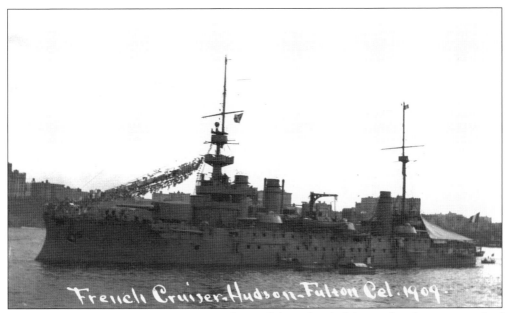

FRENCH CRUISER. France sent a squadron of three battleships under the command of Adm. Jules L. M. le Pord. According to the *New York Times* of September 21, 1909, the French ships *Verite*, *Liberte*, and *Justice* were the first foreign ships to arrive at the North River for the celebration and were greeted with a roaring gun salute and responded with the same. The ships were manned by 1,000 officers and sailors. (Azo.)

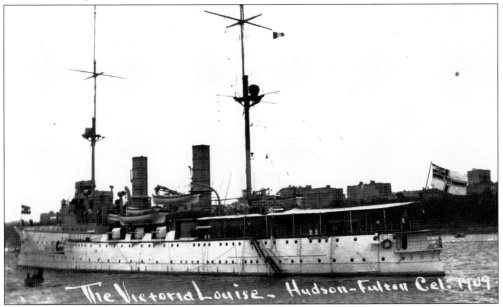

GERMAN *VICTORIA LOUISE*. Germany was represented by the turbine cruiser SMS *Dresden*, the training ships SMS *Hertha* and SMS *Victoria Louise*, and the cruiser SMS *Bremen*. Emperor Wilhelm II's fleet admiral did not join this squadron, leaving Admiral Seymour the highest-ranking foreign military officer. Wilhelm II was the last German emperor and the king of Prussia from 1888 to 1918. These warships certainly fought in World War I, but history has told of Germany's insufficient armaments. (Azo.)

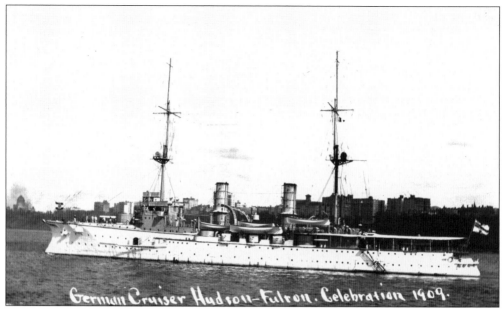

GERMAN CRUISER. This real photograph is of a handsome German cruiser floating along the Hudson River for the naval parade. The *Victoria Louise,* seen here flanked by flags with the German cross, carried the same name as the emperor's youngest daughter. His seventh child lived from 1892 to 1980. Manhattan is the background with Grant's Tomb at the far left. A flag with the iron cross may be seen waving on the bow. The imperial war flag of the day may be seen on the stern of the vessel. (Azo.)

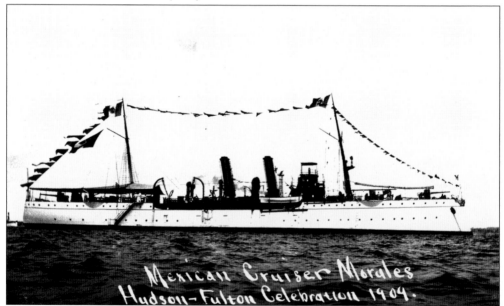

MEXICAN CRUISER *MORALES*. Program reports supported Mexican representation by the gunboat *Bravo* under the command of Capt. Manuel E. Izaguirre. This picture is of the handsome cruiser the *Morales,* which must have either joined or replaced the *Bravo.* Sunday services the following day were held with featured observances at four locations of the Reformed Protestant Dutch Church of New York City, first organized in 1628. (Azo.)

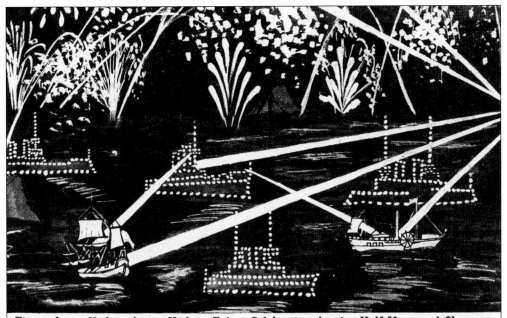

Fireworks on Hudson during Hudson-Fulton Celebration showing Half Moon and Clermont.

FIREWORKS ON HUDSON. On Saturday evening, September 25, starting at 7:00 p.m., the naval parade was repeated again with illuminations of the parade and the fleet. On the riverfront and at Grant's Tomb, batteries of searchlights arched the river with floods of light. The following evening concerts were held at Carnegie Hall featuring Irish music and at the Hippodrome featuring German singers. (F.H. Company.)

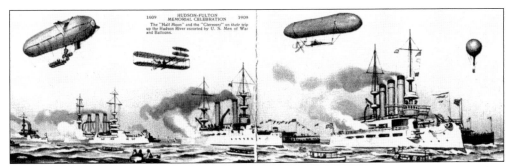

MEMORIAL VIEW. This illustrated half of a four-part foldout postcard has the naval parade alive in all its glory. Painted in white, the powerhouse United States battle assembly became known as the Great White Fleet. The fleet toured the world between 1907 and 1909 demonstrating power and diplomacy at the command of Pres. Theodore Roosevelt. An honorary assignment in 1907 was a ceremonial visit to the Jamestown Exposition in Virginia. (P. Sander.)

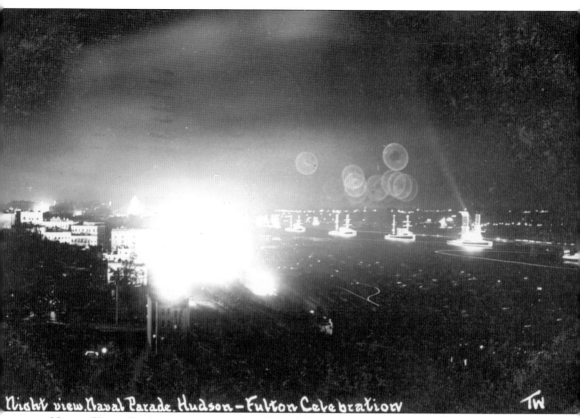

Night view. Naval Parade. Hudson – Fulton Celebration

TW

NIGHT VIEW. Beginning on September 25 and for each evening in the following two weeks, lights illuminated public buildings, avenues along the parade route including Riverside Drive, the East River Bridges, public monuments, private clubhouses, and prominent buildings. On Monday September 27, 1909, the Palisades Park along 13 miles of the Hudson River shore from Fort Lee, New Jersey, was dedicated. (T. Wilkerson.)

Three

The Parade of History

Real Photograph of the Court of Honor. On Tuesday, September 28, 1909, the celebration's great historical parade was held. The Hudson-Fulton Celebration Commission's official reviewing stands were located in front of the New York Public Library building on Fifth Avenue between 40th and 42nd Streets. The library, which officially opened in 1911, may be seen in the background. (Cyko.)

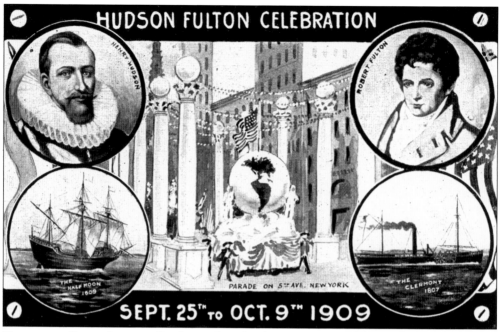

PARADE ON FIFTH AVENUE. Foreign nations, local societies and organizations, police, mounted police, escorts, and bands participated in the historical parade. A procession of 54 floats represented the principal regional historical events. The floats were divided into four divisions, Native American, Dutch, Colonial, and United States and Modern. Pageantry commenced at 1:00 p.m. in Manhattan and was repeated in Brooklyn on October 1.

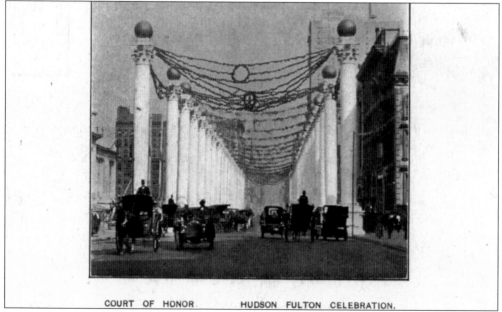

UNIVERSAL COURT OF HONOR. Early automobiles and carriages may be seen passing through the Court of Honor. In addition to the parade on September 28, the Bronx held a banquet, Brooklyn held literary exercises, and the Metropolitan Opera House and Carnegie Hall held German music festivals. (The Universal Post Card Company.)

HENDRIK HUDSON, 1609. Chief to the history, the explorer Henry Hudson was a citizen of London. Only four years of his history are known, from 1607 to 1611. Hudson made four voyages to America, sailing from Amsterdam on his third voyage on April 14, 1609. On September 3, 1609, in the Dutch *Half Moon*, his ship anchored in New York Bay and entered the Hudson River nine days later, a week later reaching Albany. On return, Hudson reached Dartmouth, England, on November 7, so the British learned of his discovery first. (Jerome H. Remick and Company.)

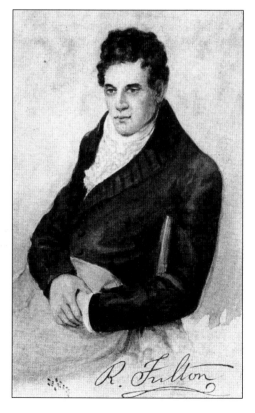

ROBERT FULTON. Chief to the industry, the inventor Robert Fulton was born in Lancaster County, Pennsylvania, in 1765. His first study was in fine arts, although he later switched to engineering. His first pursuits led him to Philadelphia where he derived a living for four years from painting portraits and landscapes and making models of machinery. His contemporary, Benjamin Franklin became an acquaintance. (Jerome H. Remick and Company.)

THE FULTON HOMESTEAD WASHINGTON COUNTY, PENNSYLVANIA. On his 21st birthday, Robert Fulton took his mother and sisters to Washington County and purchased for $400 a farm, which became known as the Fulton Homestead and is approximately 30 miles southwest of Pittsburgh. (The Churchman Company.)

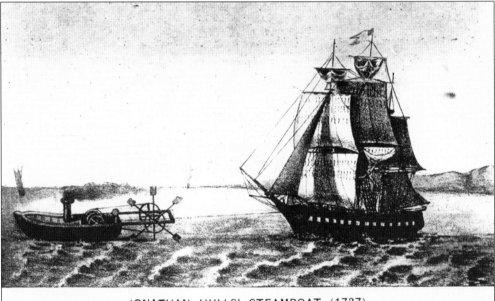

JONATHAN HULLS' STEAMBOAT (1737)

JONATHAN HULLS STEAMBOAT, 1737. The first steamboat patent belongs to Jonathan Hulls's published pamphlet of 1737. This first suggestion of paddle wheel drive from the boat's stern occurred to Hulls through observation of geese and ducks that pushed webbed feet behind them to accelerate. Hulls hoped these odd oars could paddle boats similarly against tide and wind. (The Churchman Company.)

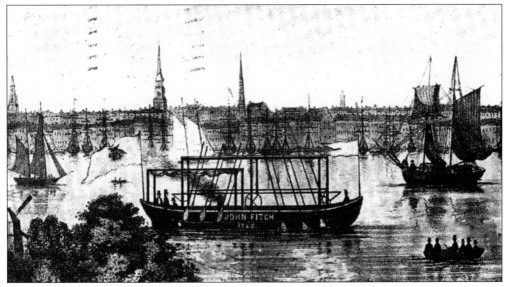

JOHN FITCH'S STEAMBOAT AT PHILADELPHIA. In 1786, Fitch made several experiments on the Delaware River and is credited with the first successful steamboat using a paddle propelled by steam power. Fitch died of an overdose in 1798. Meanwhile, Fulton experimented with torpedo boats and steamboats. In 1801, with United States ambassador to France Robert R. Livingston Jr., a steamboat was successfully put in the Seine. The body proved too weak and sunk. (The Churchman Company.)

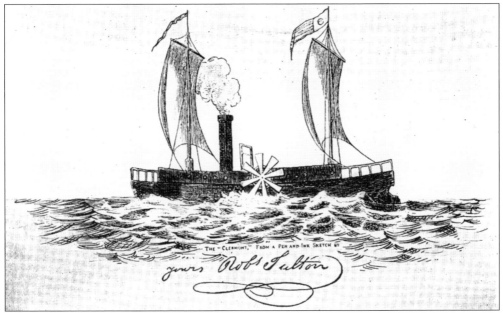

ROBERT FULTON'S SKETCH OF THE *CLERMONT*. After proposing steam power to Napoleon Bonaparte, Fulton returned to New York after unsuccessful attempts to gain the emperor's interest. His first successful steamer, the *Clermont*, was followed by ferry service from New York and to Jersey City and Brooklyn. Later the round-trip fare to Albany started at $14. Fulton was commissioned to build a battleship in 1814 but died a year later before its delivery. (The Churchman Company.)

LAND IN ZICHT. These Dutch souvenirs show Henry Hudson's *Vlieboot*, which is flyboat or small, fast rig named after the North Sea Channel, Vlie. Only 59 feet along the waterline, the boat was specially designed to take on the high seas. Hudson's discovery was followed in June 1611 by an unknown fate. Hudson is said to have been set adrift in Hudson's Bay with a few companions. The Dutch monarchy is famous for women who have reigned since 1890, when Queen Wilhelmina inherited the throne at the age of 10. Wilhelmina visited New York for the celebration and importantly helped her country remain neutral during World War I. (Gebroeders Binger Amsterdam.)

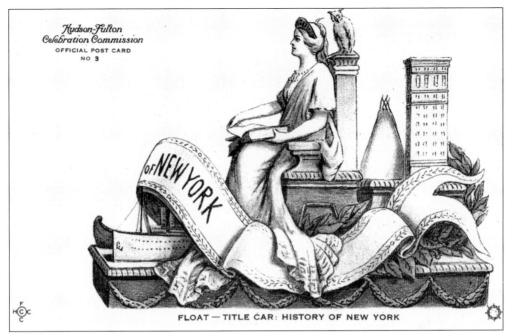

FLOAT — TITLE CAR: HISTORY OF NEW YORK

No. 3 Float Title Car, History of New York. This title car for the historical parade represented the Empire State or state of New York with canoes and the modern skyscraper. The title car for the Native American period followed with an oversized headdress surrounded by typical plants and animals of the region, including beavers and corn. These magnificent card sketches capture the parade's beauty by the official publisher. (Redfield Brothers Inc.)

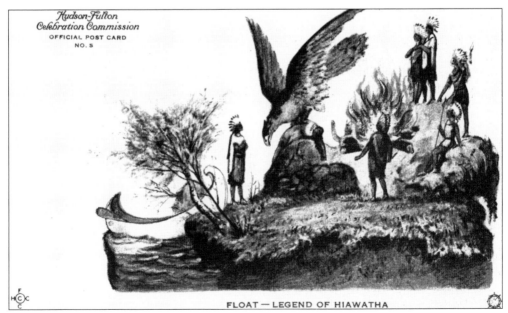

FLOAT — LEGEND OF HIAWATHA

No. 5 Float, Legend of Hiawatha. The Iroquois have a legend of their final union into a confederacy. Great Chief Hiawatha ceased tribal fighting by calling representatives together to a great council on the banks of Lake Onondaga, near Syracuse. (Redfield Brothers Inc.)

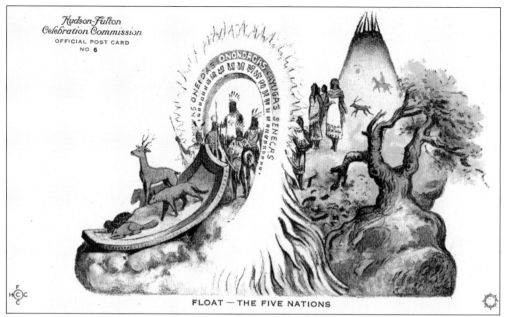

FLOAT — THE FIVE NATIONS

No. 6 Float, Five Nations. The Native American confederacy was originally comprised of five related nations, the Mohawk, Oneida, Onondaga, Cayuga, and Seneca. In 1714, the Tuscarora were driven out of North Carolina and received into the Iroquois Confederacy, which thereafter became known as the Six Nations. (Redfield Brothers Inc.)

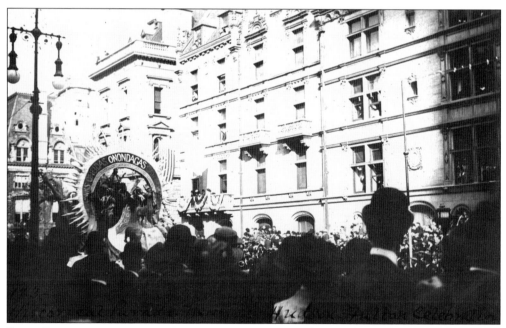

Real Photograph of the Float Five Nations. Along the avenues, in the stands, and from building windows, thousands gathered in their best suits and hats to watch the parade pass. This float included Native Americans waving to the crowds, representations of local flora and fauna, a magnificent headdress, and a tepee. Banners and flags wave all around, lining the streets and surrounding neoclassical buildings. (Cyko.)

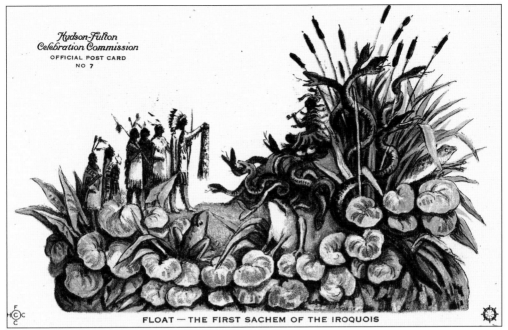

FLOAT — THE FIRST SACHEM OF THE IROQUOIS

No. 7 Float, First Sachem of the Iroquois. The first sachem or leader of the Iroquois League was the venerable Atotarho, a famous Onondaga chief. The Native American traditions represented him as living in a swamp, where his dishes were made from enemies' skulls. Atotarho was greatly feared in his cloths of hissing snakes. (Redfield Brothers Inc.)

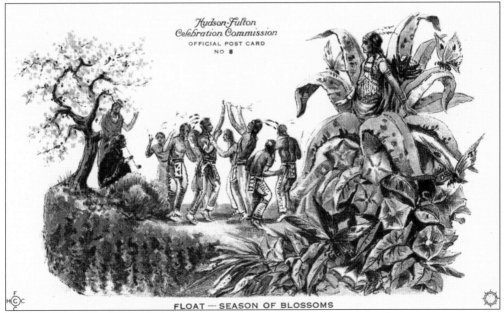

FLOAT — SEASON OF BLOSSOMS

No. 8 Float, Season of Blossoms. This float demonstrates spring for Native Americans. The season is said to include a ceremonial dance as invocation to the Great Spirit for good crops. Pipe smoking accompanies the festivities. Apple trees and morning glories add color. Some natives called the Hudson River Cahohatatea or "river that flows from the mountains." New York State ranks second in apple production in the United States. (Redfield Brothers Inc.)

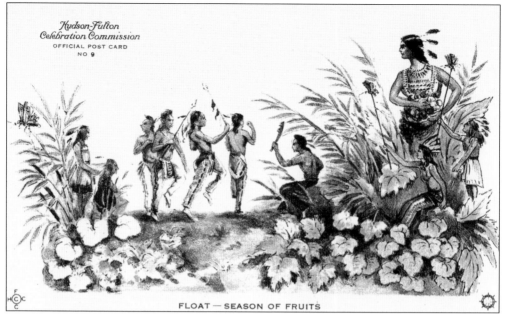

FLOAT — SEASON OF FRUITS

NO. 9 FLOAT, SEASONS OF FRUITS. The summer season was known as the season of fruits. Two important crops were celebrated separately. Hamendayo celebrated the berry festival. Ahdakewao celebrated the green corn festival. The Great Spirit continues to watch over her people. (Redfield Brothers Inc.)

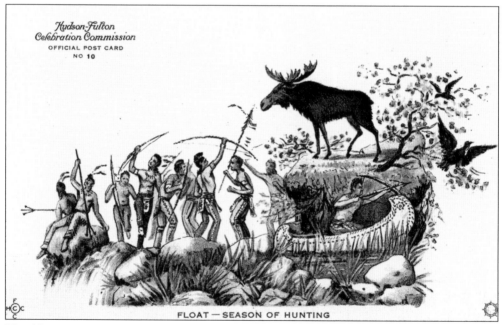

FLOAT — SEASON OF HUNTING

NO. 10 FLOAT, SEASON OF HUNTING. Autumn brought the hunting season to natives. With the onset of cold weather, all efforts were made to store food for hard times. Waterfowl and moose became targets. A canoe hides gracefully among the reeds. Other natives called the Hudson River Mahicanituk or "place of the Mohicans." (Redfield Brothers Inc.)

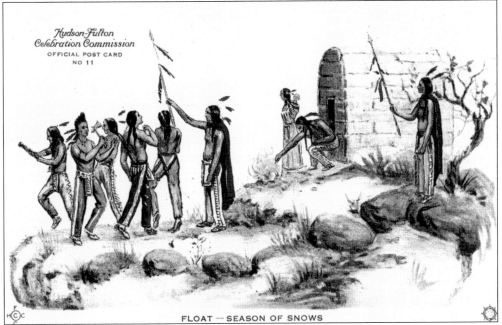

NO. 11 FLOAT, SEASON OF SNOWS. The Season of Snows float represents the dance to appease the Great Spirit. Natives asked for softer effects of winter that at one time killed many of the tribe. A woman carrying a child in a papoose looks over the dance. A fire is stoked to placate the spirit while men with tomahawks, feathers, and arrows dance. (Redfield Brothers Inc.)

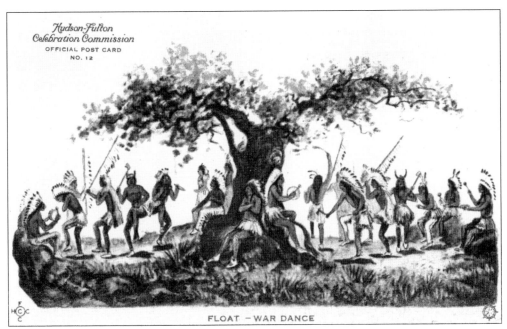

NO. 12 FLOAT, WAR DANCE. The war dance depicted was used to arouse the enthusiasm and enlist warriors for dangerous expeditions as war parties gathered. The dance was held in the evening with a range of 15 to 30 men performing. (Redfield Brothers Inc.)

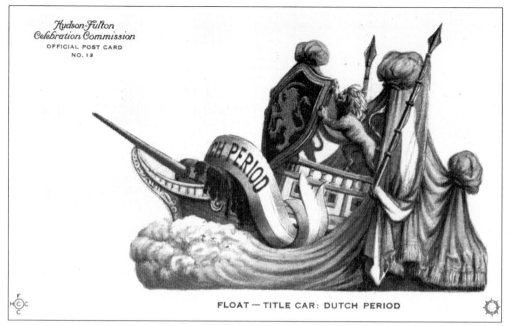

Hudson-Fulton
Celebration Commission
OFFICIAL POST CARD
NO. 13

FLOAT — TITLE CAR: DUTCH PERIOD

NO. 13 FLOAT, TITLE CAR DUTCH PERIOD. This title car shows the seal of the Dutch and indicates the importance of trade with the Native Americans in the Dutch period. The Dutch were the first to settle the area and called the river Mauritius after their crown prince Maurice, son of then leader William of Orange. (Redfield Brothers Inc.)

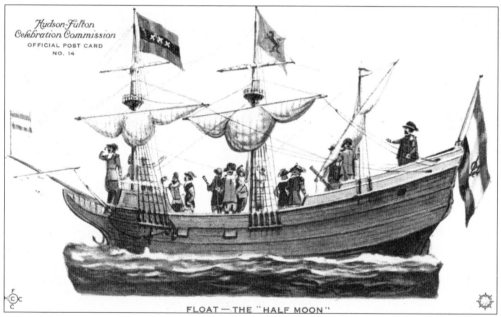

Hudson-Fulton
Celebration Commission
OFFICIAL POST CARD
NO. 14

FLOAT — THE "HALF MOON"

NO. 14 FLOAT, THE *HALF MOON*. Although small in size and population, the Dutch led the world in the industry of and trade on the seas, in fighting power, and schools. The Dutch were coming off recent successes in war against other sea powers Spain and Portugal and allowed religious freedoms that other countries did not. (Redfield Brothers Inc.)

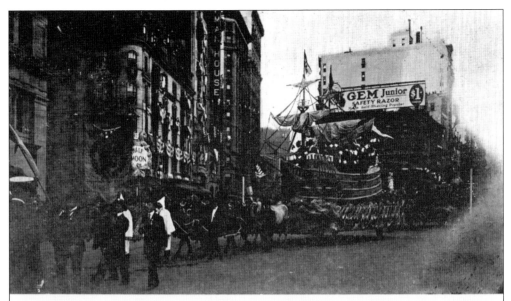

Float representing the "HALF MOON" in which Henry Hudson discovered the River which bears his name. Historical Parade Sept. 28, 1909. "Hudson-Fulton" Celebration, N.Y.

REAL PHOTOGRAPH FLOAT OF THE *HALF MOON*. In 1906, the Gem Safety Razor Company merged into Ever Ready and became the American Safety Razor Company. The dollar razor made self-shaving popular, according to the huge billboard. The company still makes razors today along with industrial and medical supplies for the worldwide market. (Empire P. and P. Company.)

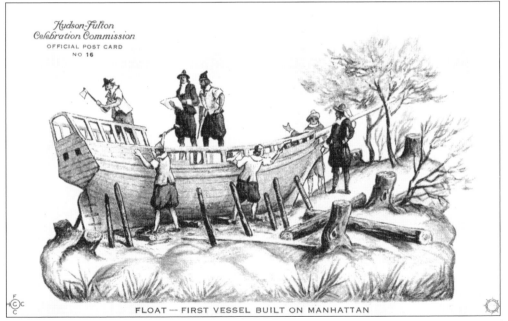

FLOAT — FIRST VESSEL BUILT ON MANHATTAN

NO. 16 FLOAT, FIRST VESSEL BUILT ON MANHATTAN. Hudson had taken possession of Manhattan in the name of the Dutch East India Company, merchants who outfitted his expedition. The first ship built in Manhattan was the *Restless*. Built by Adrian Block in the year 1614, the *Restless* replaced his ship, the *Tiger*, which was destroyed by fire. (Redfield Brothers Inc.)

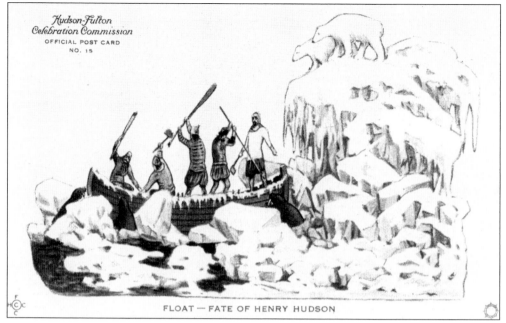

FLOAT — FATE OF HENRY HUDSON

No. 15 Float, Fate of Henry Hudson. Henry Hudson was attempting return to England after a bitter winter on his fourth sail to America. In 1610, his ship was stuck in Hudson's Bay for the winter while looking for a route to the Far East. Hudson may have been left by his crew with John, his son, who was recorded as a travel companion. Records indicate that he was in his 40s and that he was married with multiple children. (Redfield Brothers Inc.)

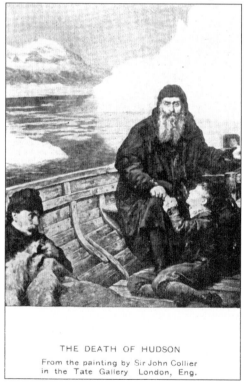

THE DEATH OF HUDSON

From the painting by Sir John Collier in the Tate Gallery London, Eng.

The Death of Hudson. From the painting by Sir John Collier in the Tate Gallery, London, Hudson's mutinous crew forced him with seven disabled crewmembers off in a small boat to an unknown fate. The mutineers returned to England, were imprisoned, and were then released without further punishment. (The Churchman Company.)

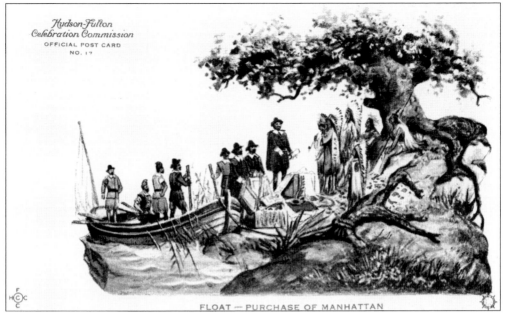

FLOAT — PURCHASE OF MANHATTAN

No. 17 Float, Purchase of Manhattan. The Dutch laid claim to the new lands upon Hudson's return. Soon early settlements commenced from Brooklyn to Albany, featuring trade and forts. In 1626, Peter Minuit was made director general with residence in New York and purchased the island from the Native Americans for trinkets or about 60 guilders, which is equivalent to $24. Fort Amsterdam was built near what is now the battery. (Above, Redfield Brothers Inc.; below, P. Sander.)

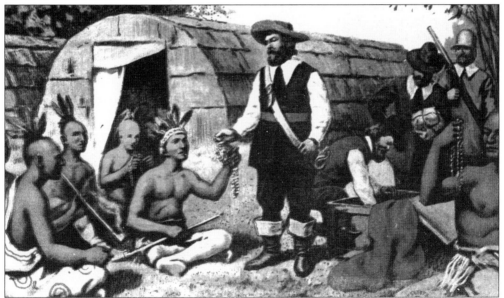

HUDSON AND POCAHONTAS. This postcard is an anomaly and may only loosely be connected to the event excepting its overprint for the celebration. The card features the baptism of Pocahontas of 1614. The card was likely recycled from the Jamestown Exposition of 1907, which occurred two years earlier to celebrate Virginia's founding, where Pocahontas was an Algonquin chief's daughter. (A. C. Bosselmen Company.)

MANHATTAN ISLAND BEFORE THE DUTCH. According to early English engravings, native peoples on Manhattan built long houses from wood with a central cooking oven. Dutch house building was recorded in 1613. In 1614, the pirate Samuel Argall forced the brief raising of English flags before sailing on. The Dutch officially chartered the land that same year. (P. Sander.)

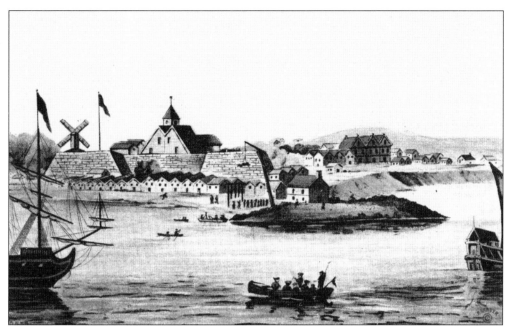

FORT AMSTERDAM, NOW THE BATTERY. In 1632, Gov. Peter Minuet was recalled and succeeded by Von Twiller, who was succeeded by William Kieft in 1637. Kieft was recalled for cruelty in 1646. The gallant Peter Stuyvesant was elected governor director general of New Netherland in 1647. (P. Sander.)

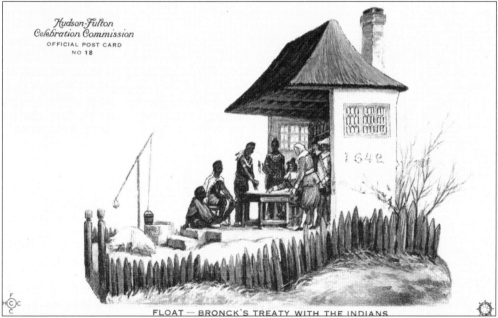

NO. 18 FLOAT, BRONCK'S TREATY WITH THE NATIVE AMERICANS. In 1639, Jonas Bronck purchased land to the north of Manhattan from the Native Americans. In 1642, after much hostility, a treaty with the Native Americans was signed in his house. The land was cut by a river that became the Bronx River. Later the New York City borough was given the same name. (Redfield Brothers Inc.)

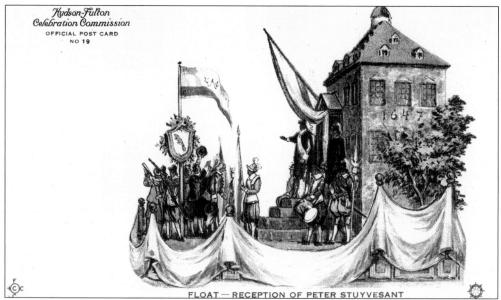

FLOAT — RECEPTION OF PETER STUYVESANT

NO. 19 FLOAT, RECEPTION OF PETER STUYVESANT. Peter Stuyvesant, the fourth and most famous governor, was appointed in 1647 after losing a leg in the Dutch service on St. Martin island. Stuyvesant had the unfortunate duty in 1664 of surrender of New Netherland to the English on August 29, 1664. Richard Nicolls had demanded Manhattan in the name of the sovereign Charles II of England. (Redfield Brothers Inc.)

ENGLISH OCCUPATION OF CITY HALL. Ten days after surrender, English rule began and the province was renamed after the Duke of York, Charles's brother. Four ships carrying 450 soldiers had been sufficient force to overcome the Dutch in relative peace. A brief interval from English rule lasted from August 1673 to November 1674, when Dutch captain Anthony Colve seized control. Dutch rule ended essentially following the signing of the Treaty of Westphalia in 1648 between major European powers of the day. (P. Sander.)

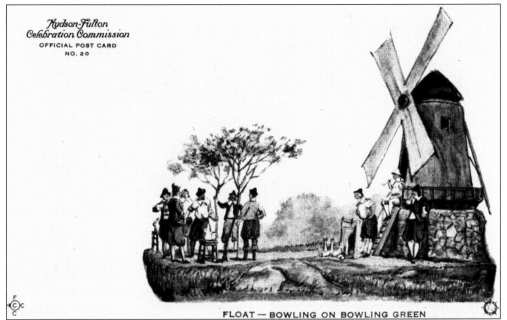

FLOAT — BOWLING ON BOWLING GREEN

NO. 20 FLOAT, BOWLING ON BOWLING GREEN. Bowling Green at the foot of Broadway is the oldest park in New York City. Originally used as a parade ground and public place for many years, in 1732 a walkway with green expanse was created. It sits across from the U.S. customs house. (Redfield Brothers Inc.)

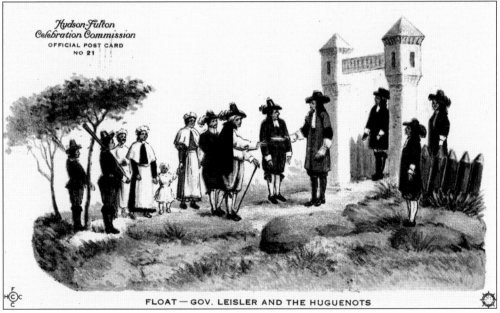

FLOAT — GOV. LEISLER AND THE HUGUENOTS

NO. 21 FLOAT, GOVERNOR LEISLER AND THE HUGUENOTS. When William and Mary were crowned king and queen of England in 1680, Gov. Francis Nicholson fled from New York. Jacob Leisler assumed control of government. Leisler was hanged as a traitor but later officially proclaimed innocent. Leisler had brokered a land purchase for the Huguenots. (Redfield Brothers Inc.)

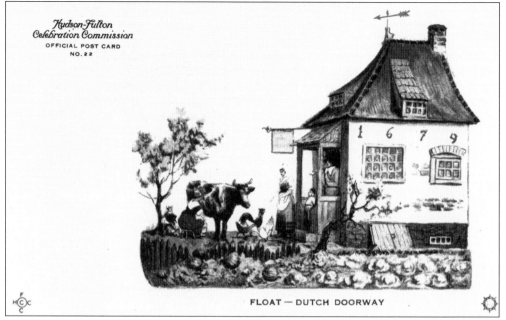

NO. 22 FLOAT, DUTCH DOORWAY. The float represents a prominent family place for resting and social purposes in that time. The Hudson River was second after the St. Lawrence to be explored in America. The Hudson is 300 miles long, with 150 miles navigable, and has tidal effects all the way to Albany. (Redfield Brothers Inc.)

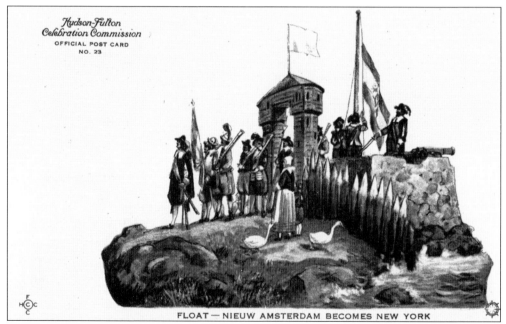

NO. 23 FLOAT, NIEUW AMSTERDAM BECOMES NEW YORK. The Duke of York at the time of the English takeover became King James II in 1685. In 1683, 10 counties were established in New York. Six of those first counties are along the Hudson River, Albany, Dutchess, New York, Orange, Ulster, and Westchester. (Redfield Brothers Inc.)

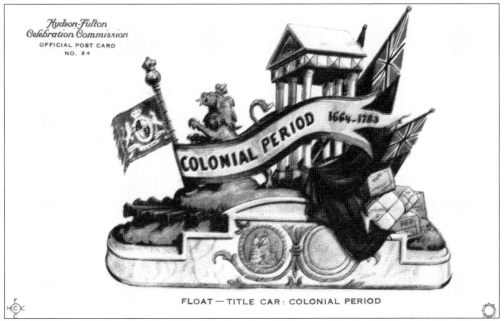

FLOAT — TITLE CAR: COLONIAL PERIOD

No. 24 Float Title Car, Colonial Period. The Colonial Period is represented by the might of Great Britain, shown by the lion resting on her army and navy, represented by cannon. At the rear of the car, chests of tea recall resistance to England's taxes, a leading symptom of the Revolution. (Redfield Brothers Inc.)

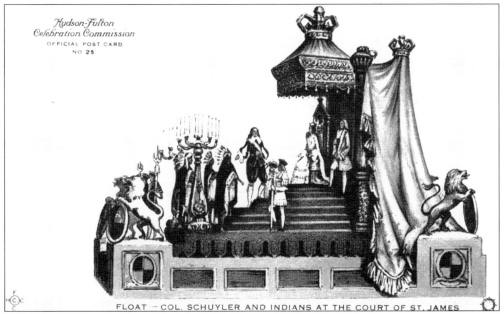

FLOAT — COL. SCHUYLER AND INDIANS AT THE COURT OF ST. JAMES

No. 25 Float, Col. Peter Schuyler and Indians at the Court of St. James. In 1692, Schuyler took five Iroquois chiefs to London to impress the chief with his home country's powers and to arouse the government to a stronger defense policy against the French in Canada. The natives garnered intense interest in the Court of Saint James, home to the head of the British state. (Redfield Brothers Incorporated New York.)

75

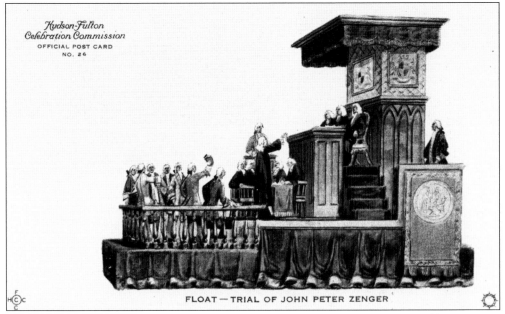

FLOAT — TRIAL OF JOHN PETER ZENGER

NO. 26 FLOAT, TRIAL OF JOHN PETER ZENGER. Zenger was editor of a small newspaper, the *Weekly Journal,* which freely criticized the arbitrary acts of the royal government. In 1735, Zenger was tried for libel and acquitted by plea of Andrew Hamilton. The legacy left was the freedom of the American press. (Redfield Brothers Inc.)

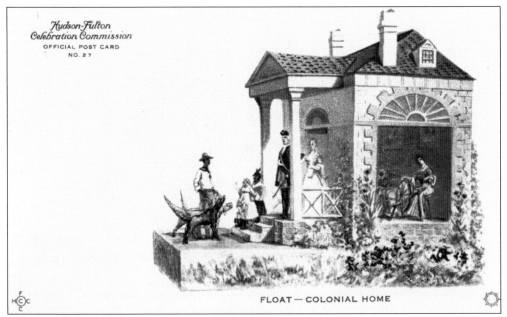

FLOAT — COLONIAL HOME

NO. 27 FLOAT, COLONIAL HOME. Domestic life in the English era is represented by weaving and spinning. The master of the house is returning from the hunt with his working dogs. Slavery work is represented through the child's attendant and the dog trainer. (Redfield Brothers Inc.)

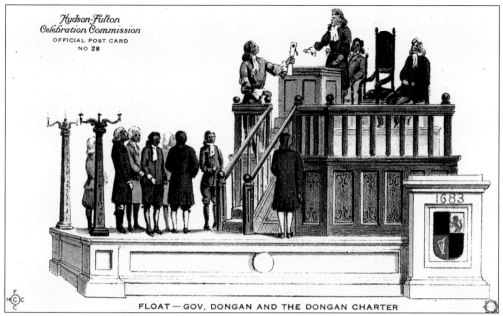

No. 28 Float, Gov. Thomas Dongan and the Dongan Charter. In 1683, Thomas Dongan declared a "Chart of Liberties" vesting legislative power in a governor, council, and a people's general assembly. The charter was the first recognition of people's rights in an America by constitution. (Redfield Brothers Inc.)

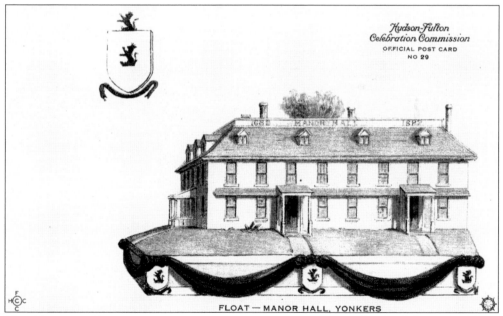

No. 29 Float, Philipse Manor Hall Yonkers. In 1693, Frederick Philipse's land from Spuyten Duyvil Creek to the Croton River was established into a royal charter as the manor of Phillipsburg. His home, the Philipse Manor Hall house, in Yonkers was built in 1686. His descendants expanded the house, and his grandson was a signer of the Declaration of Independence. (Redfield Brothers Inc.)

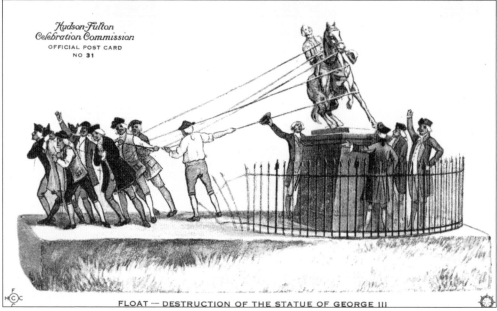

NO. 31 FLOAT, DESTRUCTION OF THE STATUE OF GEORGE III. In 1754, Benjamin Franklin drafted a union of northern colonies that was adopted in Albany but not executed. In 1764, the New York Assembly authorized discussions with other colonies on unreasonable trade and tax rules. (Redfield Brothers Inc.)

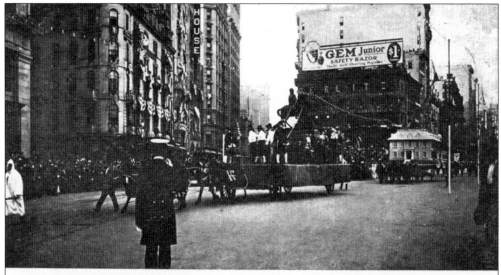

First Float represents the Destruction of the Statue of George III, July 9th, 1776.
Second Float represents Philipse Manor House in Yonkers erected in 1686.
Historical Parade, September 28th, 1909, "Hudson-Fulton" Celebration, New York.

REAL PHOTOGRAPH OF THE FLOAT DESTRUCTION OF THE STATUE OF GEORGE III. After the repeal of the Stamp Act, New York erected a lead statue of King George III on the Bowling Green in 1770. Patriots tore down the statue on July 9, 1776, and used the lead for bullets. The Manor Hall float may be seen directly behind the George III. In the background below the Gem Razor billboard, the building has huge lettering that reads, the "Berlitz School of Languages," famed to this day for translation books and courses. (Empire P. and P. Company.)

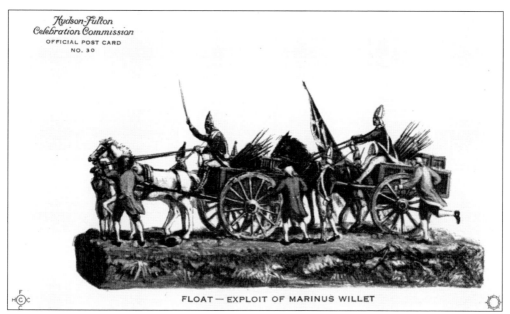

FLOAT — EXPLOIT OF MARINUS WILLET

NO. 30 FLOAT, EXPLOIT OF MARINUS WILLET. The New York area bore the brunt of the Revolution. In 1775, British troops withdrew from New York City. In June, while loading cartloads of armaments, Marinus Willet organized citizens to seize the arms for the Americans. A key battle at Saratoga in 1777 was said to have foiled British attempts to divide the northern states. (Redfield Brothers Inc.)

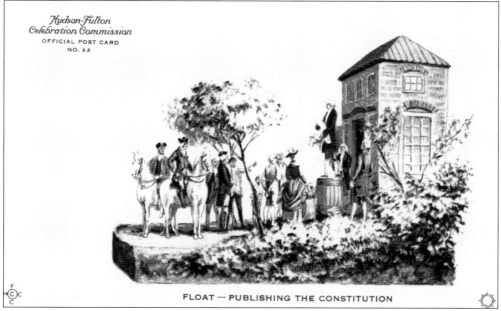

FLOAT — PUBLISHING THE CONSTITUTION

NO. 32 FLOAT, PUBLISHING THE CONSTITUTION. On April 20, 1777, New York became an independent state and the soldier George Clinton became its first governor. The Constitution was begun in White Plains, furthered in Fishkill, and finished, proclaimed, and published in Kingston. The convention was moved to escape the British and seated in Poughkeepsie and finally Albany in 1797. (Redfield Brothers Inc.)

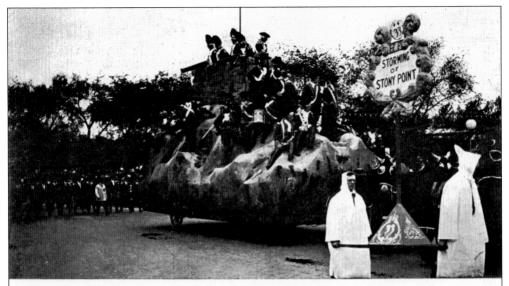

Float Representing "Storming of Stony Point," "Historical Parade," New York, Sept. 28th, 1909, "Hudson-Fulton" Celebration

REAL PHOTOGRAPH OF THE FLOAT STORMING OF STONY POINT. Featuring the bluecoat Americans surrounding redcoat British men, this float is aligned as the 33rd event in the parade with hooded men holding numbered signage. Draped horses pull the float on tiny wheels. American Continentals escort the float. Marching policemen follow the float in procession. This representation is from midnight, July 15 and 16, 1779, when Gen. Anthony Wayne and about 1,200 men captured by surprise British position thought to be impregnable. (Cyko.)

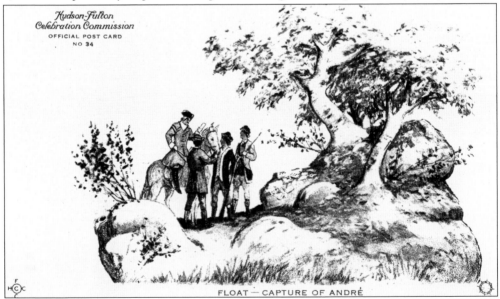

FLOAT — CAPTURE OF ANDRÉ

NO. 34 FLOAT, CAPTURE OF ANDRE. Maj. John André of the British Army was the intermediary through which Benedict Arnold and the British commander conducted secret negotiations. The betrayal nearly lost West Point to the British for gold to repay Arnold's debt. Arnold was a trusted lieutenant in George Washington's army. André was captured near Tarrytown in 1780 and hanged for spying. (Redfield Brothers Inc.)

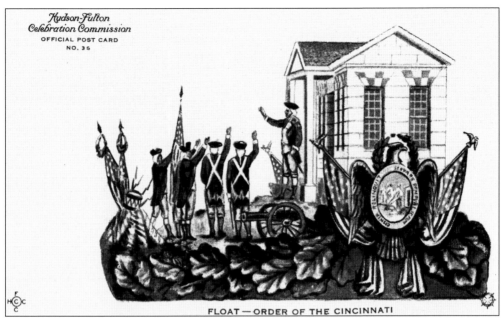

FLOAT — ORDER OF THE CINCINNATI

NO. 35 FLOAT, ORDER OF THE CINCINNATI. This order was formed near Newburgh in 1783 to perpetuate the memories of the Revolution. Composed of the descendants of American and French army officers, the order is the oldest hereditary society in the United States. (Redfield Brothers Inc.)

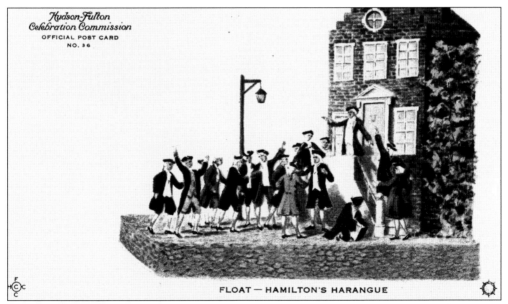

FLOAT — HAMILTON'S HARANGUE

NO. 36 FLOAT, HAMILTON'S HARANGUE. At a public meeting on July 18, 1795, at the old city hall, Alexander Hamilton attempted to quiet an unruly debate on a proposed treaty with Great Britain. Disorder ruled, and Hamilton was knocked down from his perch on a Dutch house and dragged through the streets. (Redfield Brothers Inc.)

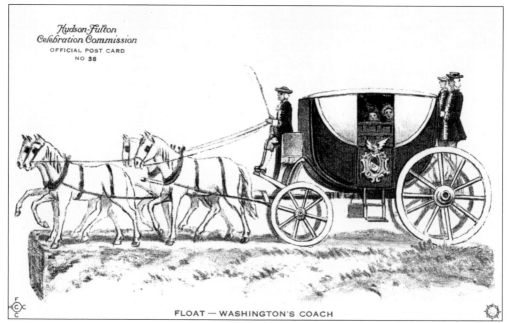

FLOAT — WASHINGTON'S COACH

NO. 38 FLOAT, GEORGE WASHINGTON'S COACH. A reminder of grander, slower days, George Washington was offered royal status as king in 1782 at his headquarters in Newburgh. Refusing and sternly rebuking his devoted officers, Washington disbanded the Continental army the following year. (Redfield Brothers Inc.)

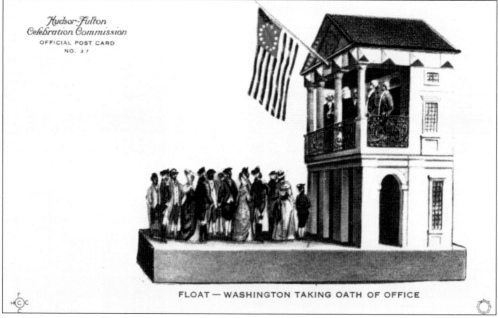

FLOAT — WASHINGTON TAKING OATH OF OFFICE

NO. 37 FLOAT, GEORGE WASHINGTON TAKING OATH OF OFFICE. In Federal Hall on April 30, 1780, Washington was inaugurated as first president of the United States. The oath of office was administered by the chancellor of the state of New York, Robert R. Livingston Jr., from the balcony facing Broad Street at the corner of Wall and Nassau Streets. Livingston was a patron of Robert Fulton and negotiated the Louisiana Purchase from France. (Redfield Brothers Inc.)

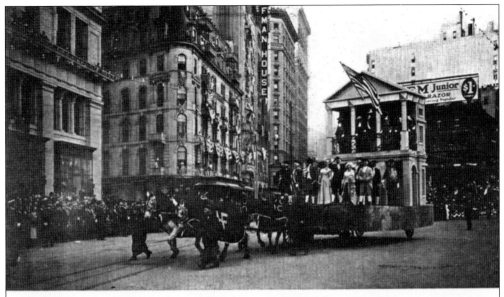

Float representing Washington taking oath of office, as the first President of the United States, Historical Parade Sept. 28th, 1909, "Hudson-Fulton" Celebration, New York

REAL PHOTOGRAPH OF THE FLOAT WASHINGTON TAKING OATH OF OFFICE. New York remained the seat of government until December 1790. This building was later demolished, and the location became the treasury, which is now a national monument. The escorts for Washington's floats were the Sons of the American Revolution and the Continental Guard. (Empire P. and P. Company.)

REAL PHOTOGRAPH CLASSICAL BUILDINGS. This photograph displays parade decorations similar to that found on Federal Hall. Historical events and locations filled the area. Alexander Hamilton was fatally wounded by Aaron Burr on July 11, 1804, at Weehawken. Presidents Martin Van Buren, Chester Arthur, Theodore Roosevelt, Grover Cleveland, and Franklin Roosevelt came from New York. (Cyko.)

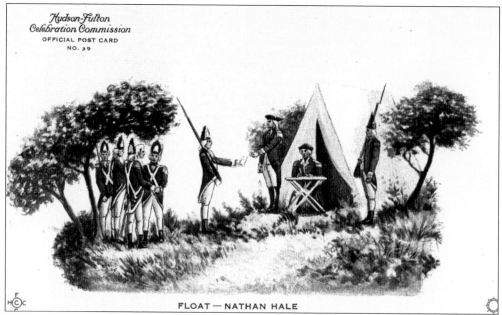

FLOAT — NATHAN HALE

No. 39 Float, Captain Nathan Hale. Nathan Hale volunteered to enter British territory to spy on their plans. Disguised as a schoolteacher through Connecticut and the Long Island Sound, he was discovered and hanged on September 21, 1776, regretting that he had but one life to give for his country. (Redfield Brothers Inc.)

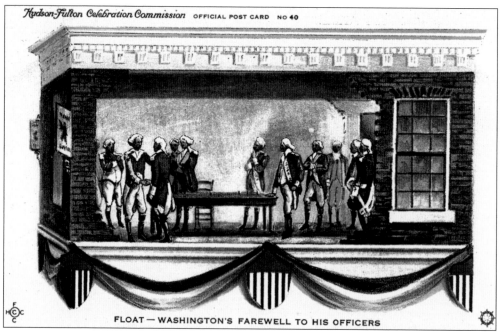

FLOAT — WASHINGTON'S FAREWELL TO HIS OFFICERS

No. 40 Float, Washington's Farewell to His Officers. On December 4, 1783, George Washington bid farewell to his officers at Fraunce's Tavern at the corner of Pearl and Broad Streets. Washington proceeded to Annapolis to resign his military position. The tavern was established in 1762 and is a famed restaurant and landmark to this day. (Redfield Brothers Inc.)

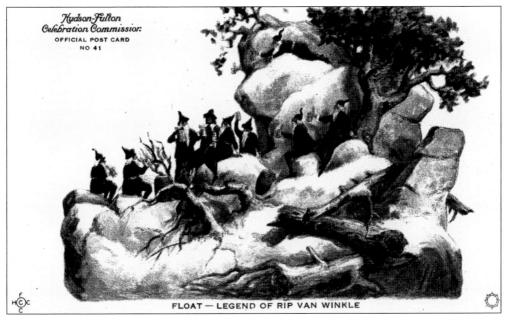

FLOAT — LEGEND OF RIP VAN WINKLE

No. 41 Float, Legend of Rip Van Winkle. Fictional Rip Van Winkle was a good-natured, reclusive Dutchman said to drink liquor with Henry Hudson's ghostly crew in the Catskills. In this classic tale by Washington Irving, Winkle gets into trouble after a 20-year sleep through the Revolutionary War when he awakes and proclaims allegiance to King George III. (Redfield Brothers Inc.)

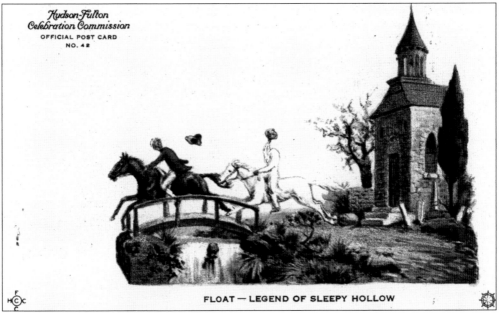

FLOAT — LEGEND OF SLEEPY HOLLOW

No. 42 Float, Legend of Sleepy Hollow. Near Tarrytown, this Washington Irving story tells of nightly pursuits of Ichabod Crane by a headless horseman. The Hessian soldier supposedly threw his head at Crane as the Sleepy Hollow Bridge was crossed. Crane was courting a wealthy young lady, who was lost to another suitor suspected of orchestrating the hoax. (Redfield Brothers Inc.)

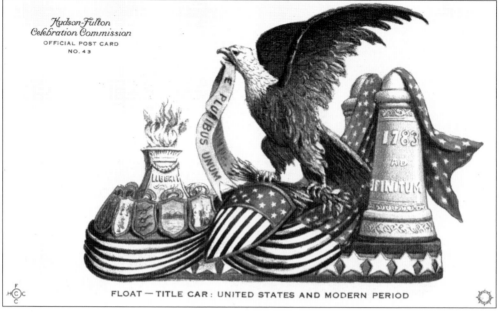

FLOAT — TITLE CAR: UNITED STATES AND MODERN PERIOD

No. 43 Float Title Car, United States and Modern Period. The fourth parade division represented achievements through the 19th century. Columbia University was established in 1784. A key commercial milestone was the opening of the Erie Canal on October 26, 1825, that connected Lake Erie to the Atlantic Ocean through the Hudson River. (Redfield Brothers Inc.)

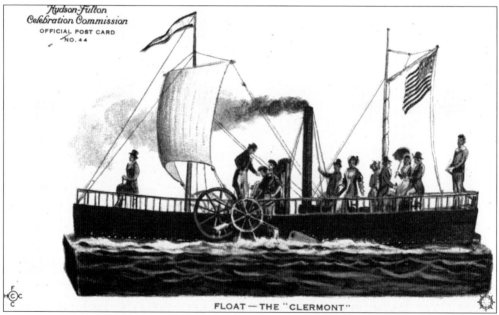

FLOAT — THE "CLERMONT"

No. 44 Float, the *Clermont*. Celebration events continued in the Bronx on Wednesday, September 29, 1909, with a military, civic, and historical parade. That route was along Washington Avenue from East 163rd to East 187th Streets. The replica ships were docked in Yonkers for the day. (Redfield Brothers Inc.)

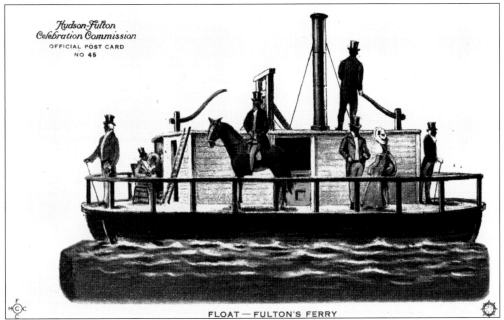

FLOAT — FULTON'S FERRY

NO. 45 FLOAT, FULTON'S FERRY. Fulton's ferry started in 1812 and was built with two hulls. The catamaran was 80 feet long and required 20 minutes to cross the Hudson River from Cortlandt Street to Jersey City. September 29, 1909, saw intership pulling races between warships and a motorboat race in Yonkers. (Redfield Brothers Inc.)

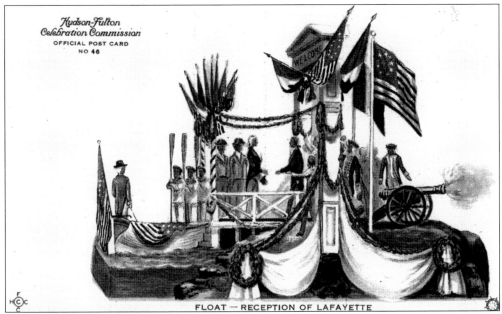

FLOAT — RECEPTION OF LAFAYETTE

NO. 46 FLOAT, RECEPTION OF THE MARQUIS DE LAFAYETTE. Following the Revolution, George Washington's friend Marquis de Lafayette returned to France. Lafayette visited the United States in 1824 and 1825 and was received with popular demonstrations and affection. On September 29, 1909, educational institutions across New York held commemorative exercises across the state honoring its history. (Redfield Brothers Inc.)

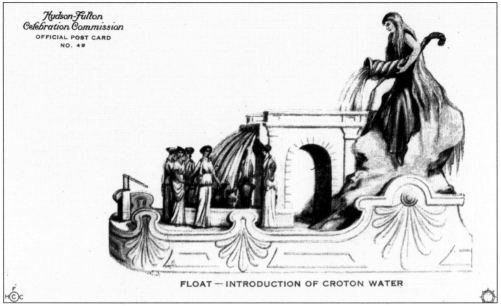

FLOAT — INTRODUCTION OF CROTON WATER

No. 49 Float, Introduction of Croton Water. The introduction of the water reservoir in New York City in 1842 was marked by huge celebrations. The water travelled via aqueduct from Westchester County, and its arrival was indicated by the gushing of a 60-foot fountain in the former portion of City Hall Park near what is now the 85th Street Central Park crossing. (Redfield Brothers Inc.)

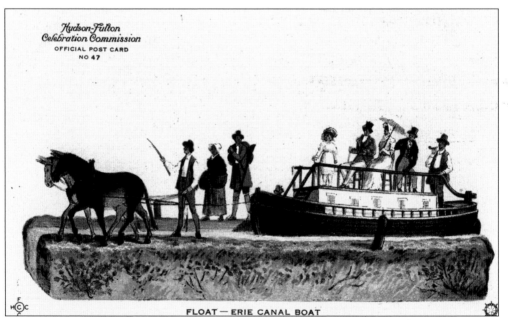

FLOAT — ERIE CANAL BOAT

No. 47 Float, Erie Canal Boat. A simple boat traverses a grand engineering feat that connected the Great Lakes to the New York Harbor, elevating New York City's commercial prowess above Philadelphia as the premier metropolis of the New World. (Redfield Brothers Inc.)

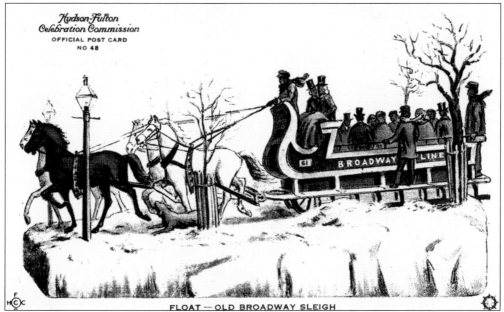

FLOAT — OLD BROADWAY SLEIGH

NO. 48 FLOAT, OLD BROADWAY SLEIGH. The sleigh represents a period long past. By 1909, tunnels, subways, elevated highways, and electronic trolleys already carried New Yorkers. Faster transportation meant cleaning snow off the streets, but in times past enterprising merchants created a sleigh line to transport pedestrians. (Redfield Brothers Inc.)

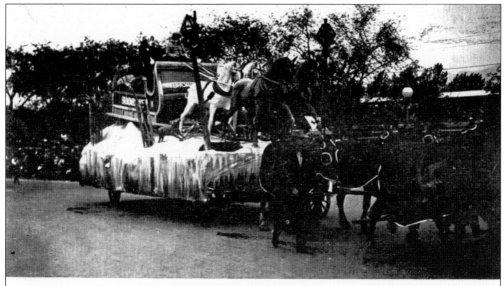

³⁷ Float Representing "Old Broadway Sleigh," "Historical Parade," New York, Sept. 28th, 1909, during "Hudson-Fulton" Celebration.

REAL PHOTOGRAPH OF THE FLOAT OLD BROADWAY SLEIGH. On September 29, 1909, the celebration continued with a children's festival on Staten Island, which was then called Richmond. Other floats not represented here include the Garibaldi's Home after the famous Italian patriot who lived briefly on Staten Island and Father Knickerbocker Receiving, referencing the Washington Irving fictional character said to represent a pioneering regional family. (Empire P. and P. Company.)

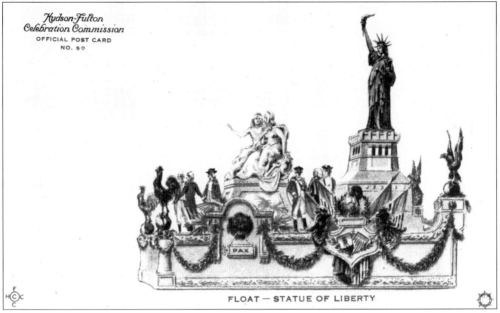

FLOAT — STATUE OF LIBERTY

NO. 50 FLOAT, STATUE OF LIBERTY. Beckon to the world and all who come ashore, the statue stands on Bedloe's Island in New York Harbor. France presented this memorial to the United States in 1886 to honor the friendship between the two countries, which commenced with the French's assistance during the American Revolution. (Redfield Brothers Inc.)

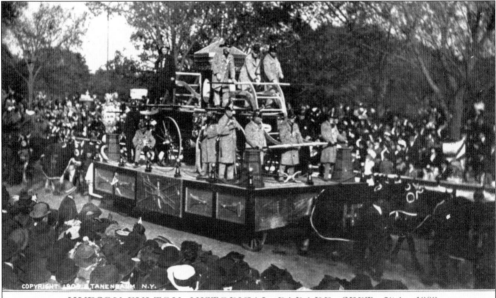

HUDSON-FULTON HISTORICAL PARADE, SEPT. 28th, 1909.
OLD FIRE ENGINE FLOAT.

REAL PHOTOGRAPH OF THE FLOAT OLD FIRE ENGINE. The float represents a gallant history of the Fire Department of New York's firefighting. The old–style, hand–powered water pump was first replaced in 1909 by a motorized fire apparatus. The float was preceded by marching veteran fireman and escorted by the exempt and volunteer fireman's association. (Empire P. and P. Company.)

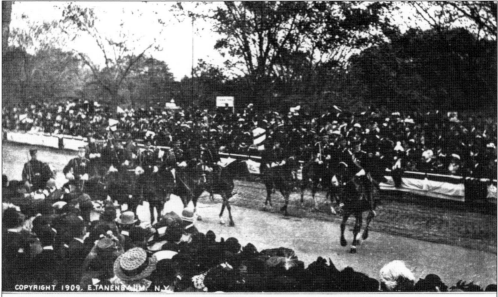

HUDSON-FULTON HISTORICAL PARADE, SEPT. 28th, 1909.
GENERAL ROE AND STAFF.

REAL PHOTOGRAPH OF GEN. CHARLES F. ROE AND STAFF. The parade was led by grand marshal Gen. Charles F. Roe along with his staff. Roe received honors in the Spanish-American War of 1898. The mayor of New York, George McClellan, followed along with the carnival and historical parade committees. (Hippodrome Publishing Company and E. Tanenbaum.)

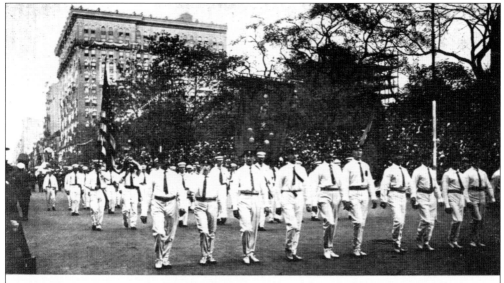

49 Swedish Societies marching in "Historical Parade," New York, Sept. 28th, 1909
"Hudson-Fulton" Celebration

REAL PHOTOGRAPH OF SWEDISH SOCIETIES. The celebration's program lists a number of societies which escorted the parade, including marching Irish, Italian, Bohemian, Hungarian, Scotch, French, Syrian, "Colored Men," and Polish societies. Norwegians escorted the first float. The Tammany Society escorted the Native American floats. Dutch floats were escorted by the United Holland Societies. The Swedish led off the Colonial floats. (Empire P. and P. Company.)

HOTEL BREVOORT — CAFÉ LAFAYETTE -
NEW YORK

DINNER $1.25

25c. extra for each Dinner taken without Wine.
From 5 to 9 o'clock P. M.

Tuesday, September 28, 1909

Blue Points

RELISHES

Cucumbers Olives

SOUPS

CHOICE { Potage Médicis Consommé Bataille
Cold Consommé

FISH

CHOICE { Spanish Mackerel, Mirabeau
Broiled Whitefish, Potatoes Duchesse

ENTREES

CHOICE { Minced Sweetbread, Lucullus
Larded Loin of Beef, Bernard

VEGETABLES

CHOICE { Succotash à la Crême
Spaghetti à l'Italienne

ROASTS

CHOICE { Broiled Squab Chicken on Toast Lamb, Mint Sauce
Pâté de Foie aux Truffes

Salads in Season

ENTREMETS

CHOICE { Mousse aux Pistaches Biscuit Tortoni
Savarin aux Fruits

Gruyère Roquefort Fruits
Demi-Tasse

Choice Seats for all Theatres may be secured at the office.
A check will be given by the waiter to patrons who desire to have their coffee served in the Cafe
Try a Jap, - 30c.

1609 — Souvenir of Hudson - Fulton Celebration — 1909

SOUVENIR MENU (OVERSIZED THREE-CARD FOLDOUT). This magnificent card features Henry Hudson and Robert Fulton and their transports along with the foreign steamer the SS *La Provence*. The tri-fold card folds out and reveals the full menu served at the Café Lafayette in the Hotel Brevoort for dinner on Tuesday, September 28, 1909. Dinner was $1.25 or "25¢ extra for each Dinner taken without Wine." Blue Point oysters start the evening and are followed by choices of soup, fish, entrée, vegetable, roast, salads, and desserts or entremets. Fruit, cheese, and demitasse coffee follow.

Four

THE MILITARY PARADE

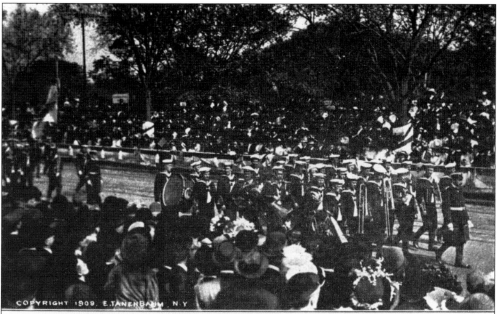

HUDSON-FULTON GREAT MILITARY PARADE, SEPT. 30th, 1909.
SAILORS FROM GERMAN BATTLESHIPS.

MILITARY PARADE GERMAN SAILORS. The military parade took place in Manhattan starting at 1:00 p.m. on Thursday, September 30, 1909. This parade was led by mounted police and then followed by the grand marshal and his staff with a squadron of the National Guard as escort. Interspersed with musicians, eight divisions of military men marched. Five years after the celebration, the world was at war with the Germans, who aligned themselves with Austria-Hungary upon the assassination of Archduke Ferdinand by a Serbian. (Hippodrome Publishing Company and E. Tanenbaum.)

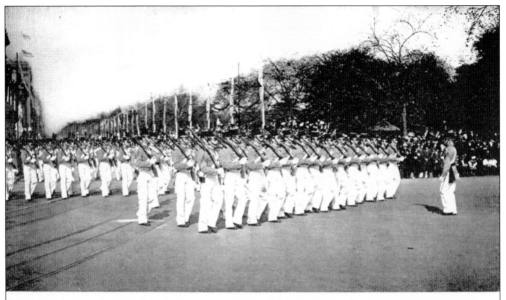

25 West Point Cadets Marching in the Military Parade, New York, Sept. 30th, 1909
"Hudson-Fulton" Celebration.

WEST POINT CADETS AND FRENCH SAILORS. At the official reviewing stand, the Grand Army of the Republic held court as guard of honor. The parade was led by the United States Army in the first division and followed by marines and sailors of foreign navies in the second division. Gen. George Washington considered West Point's commanding plateau to be an important strategic position. It is the oldest continuously operated military post in America, and Thomas Jefferson signed legislation that established the United States Military Academy there in 1802. (Empire P. and P. Company.)

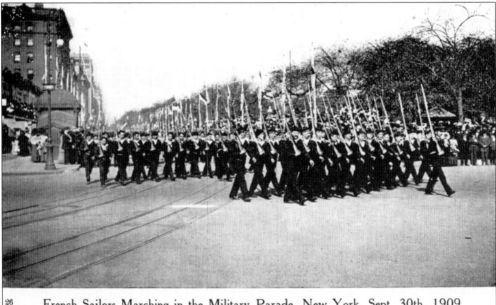

26 French Sailors Marching in the Military Parade, New York, Sept. 30th, 1909
"Hudson-Fulton" Celebration.

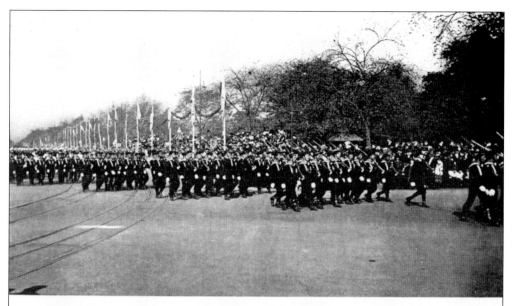

Italian Sailors Marching in the Military Parade, New York, Sept. 30th, 1909
"Hudson-Fulton" Celebration.

ITALIAN SAILORS AND DUTCH MARINES. The third division was composed of United States Marines. The fourth division included the National Guard of New York, including cavalry, coastal artillery corps, and infantry brigades. The fifth division was the naval militia. The sixth division included military and social organizations. The seventh division was Spanish–American War veterans. The eighth division included foreign military societies and the Sons of Veterans. (Empire P. and P. Company.)

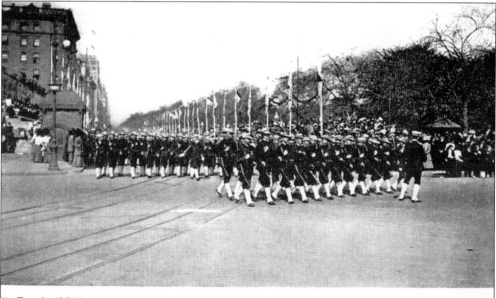

28 Dutch (Holland) Marines Marching in the Military Parade, New York, Sept. 30, 1909
"Hudson-Fulton" Celebration.

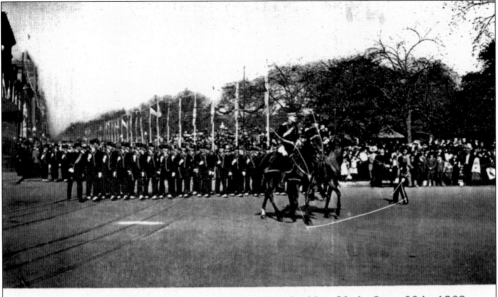

29 Italian Marines Marching in the Military Parade, New York, Sept. 30th, 1909
"Hudson-Fulton" Celebration.

ITALIAN AND BRITISH MARINES. In addition to the military parade on September 30, the celebration offered boat races on the Hudson, a literary exercise in the Bronx, and a banquet on Staten Island. Above the heads of the marchers, rows of reviewing stands may be seen jammed with onlookers. West Point graduates gained national recognition during the Mexican and Indian Wars and dominated the highest ranks during the Civil War. Notable West Point graduates include Robert E. Lee, William Tecumseh Sherman, Ulysses Grant, Stonewall Jackson, John J. Pershing, Douglass McArthur, George Patton, Dwight Eisenhower, Buzz Aldrin, and Norman Schwarzkopf. (Empire P. and P. Company.)

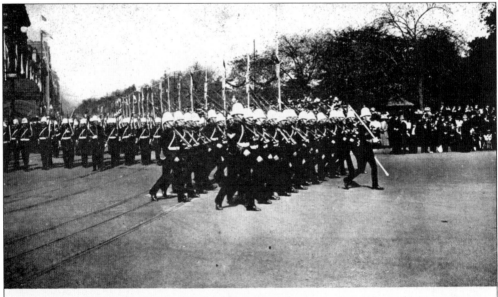

30 British Marines Marching in the Military Parade, New York, Sept. 30th, 1909
"Hudson-Fulton" Celebration

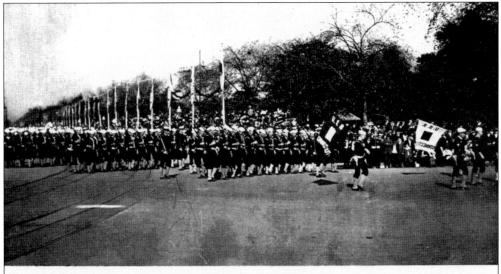

American Sailors Marching in the Military Parade, New York, Sept. 30th, 1909
"Hudson-Fulton" Celebration

AMERICAN SAILORS. Naval parades continued with the *Half Moon* and *Clermont* stopping for the day at Ossining on September 30, 1909. The vessels continued to Peekskill for the evening and then Cornwall on the next morning. The ships joined with a large United States contingent for arrival in Newburgh at 12:30 p.m. on October 1. The contingent consisted of the USS *Castine*, the lead ship for four submarines, with 12 torpedo boats and a cruiser. Six squadrons of other boats joined the festivities that included steamboats, yachts, tugs, sailboats, governmental vessels, and ambulance boats. (Empire P. and P. Company.)

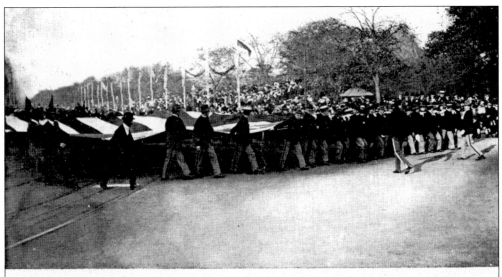

The Largest "American Flag" in the country, 100x60 ft., carried by Over 200 U. S. War Veterans in the Military Parade, Sept. 30th, 1909, "Hudson-Fulton" Celebration

LARGEST AMERICAN FLAG. This flag was carried on parade by over 200 United States war veterans. The flag was the largest American flag in the country and measured 100 by 60 feet. Assistants may be seen rushing in to help the flag turn the corner. (Empire P. and P. Company.)

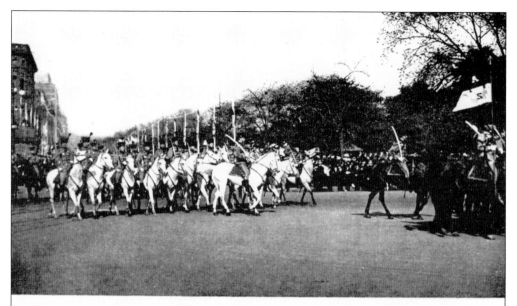

Troop A, National Guard, U. S. A., Marching in the Military Parade, New York, Sept. 30th, 1909, "Hudson-Fulton" Celebration

TROOP A NATIONAL GUARD AND WEST POINT CADET BAND. On October 1, 1909, the historical parade was repeated in Brooklyn from the Memorial Arch at Prospect Park along Eastern Avenue to Buffalo Avenue. Stand seating for 3,000 was erected. Cornwall held its own celebrations that same day replete with a historical parade with floats representing progress, music for the naval parade, and fireworks. A Native American camp on the shore was set up and dispatched canoes to meet the *Half Moon*. (Empire P. and P. Company.)

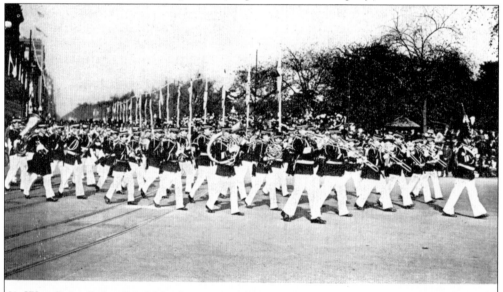

34 West Point Cadets Band Marching in the Military Parade, New York, Sept. 30th, 1909 "Hudson-Fulton" Celebration

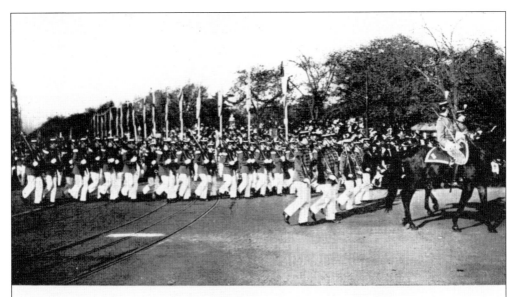

U.S. INFANTRY AND CAVALRY. The parade lasted for hours with hundreds of United States military men marching past the reviewers. The infantry was represented by the 23rd Regiment. The cavalry was from Squadron C. Both military groups were established during the Civil War in 1861. A band followed from the 7th Infantry Regiment. (Empire P. and P. Company.)

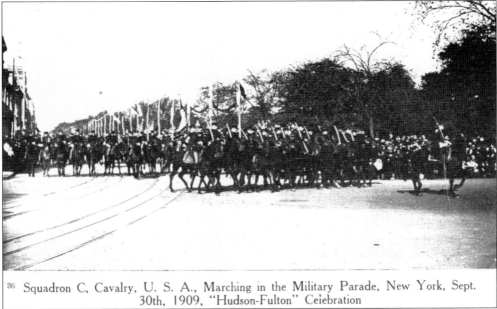

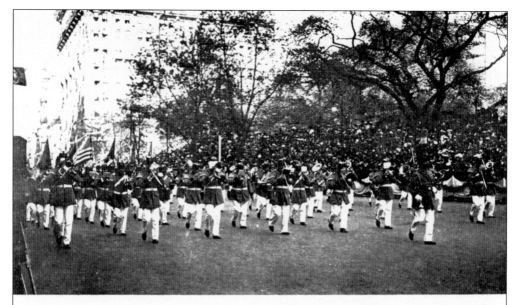

³⁸ Seventh Regiment Band, U. S. A., Marching in the Military Parade, New York, Sept. 30th, 1909, "Hudson-Fulton" Celebration

U.S. INFANTRY BAND AND OLD GUARD OF NEW YORK. The Old Guard of New York represents a historic, honorary military organization formed during the Revolutionary War. The members were known for conservatism and civic duties. Veteran assemblies were held in full regalia at social gatherings and patriotic demonstrations such as parades. The Guardsmen may be seen in tall bearskin hats usually worn as part of a ceremonial military uniform. (Empire P. and P. Company.)

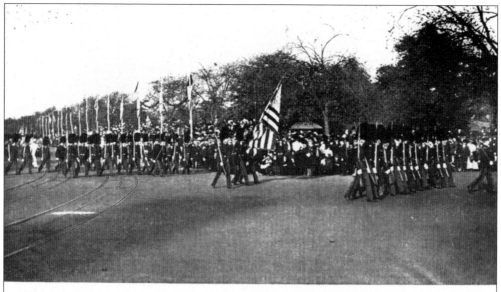

⁴⁰ Old Guard of New York, U. S. A., Marching in the Military Parade, New York, Sept. 30th, 1909, "Hudson-Fulton" Celebration.

Five

THE CARNIVAL PARADE

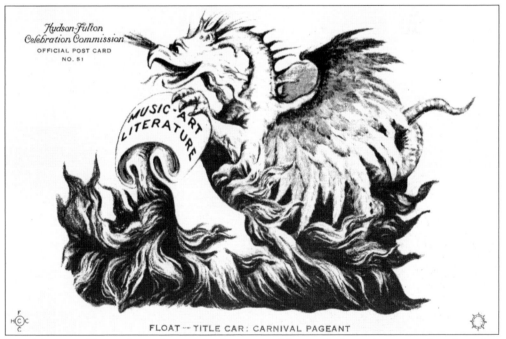

FLOAT -- TITLE CAR: CARNIVAL PAGEANT

No. 51 FLOAT TITLE CAR, CARNIVAL PAGEANT. The carnival parade occurred on Saturday, October 2, 1909, at 8:00 p.m. in Manhattan and again one week later in Brooklyn. This float led a procession of 50 floats and had a dragon spouting flames and surrounded by fire. The unconventional character saluted the myth, legend, and lore of music, art, and literature. The word *carnival* has come to mean a general public festivity. These dramatic characterizations have become part of American culture though are not indigenous. The parade was estimated to cost $250,000. The word *carnival* comes from the Latin for "farewell to flesh." Originally the term was applied to the Lenten period leading up to Ash Wednesday, proceeded by Mardi Gras. (Redfield Brothers Inc.)

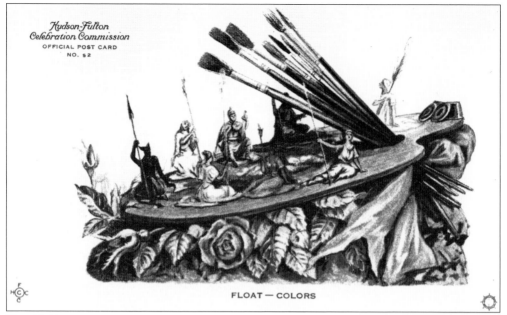

FLOAT — COLORS

NO. 52 FLOAT, COLORS. German veterans accompanied this float of Mars with its enormous tribute to colors represented by an artist palette. Austrian and Swiss societies cooperated in this parade's execution, which witnessed a heavy Germanic influence. German Americans had prospered through advancing America's industrialization leading up to this time period. (Redfield Brothers Inc.)

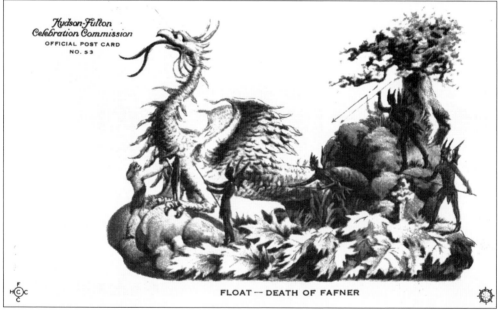

FLOAT — DEATH OF FAFNER

NO. 53 FLOAT, DEATH OF FAFNER. The United Singers of New York, of Manhattan, of the Bronx, and of Brooklyn accompanied the next floats of Song, the German favorite Lorelei, and Fafner. This German giant stole the Rheingold that was said to make the Rhine River shine. Siegfried forges a magic sword and uses it to kill Fafner, who had transposed himself into a dragon. (Redfield Brothers Inc.)

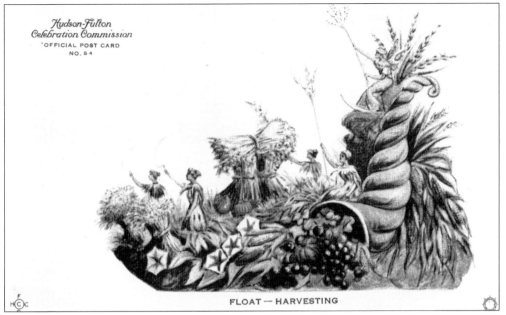

FLOAT — HARVESTING

NO. 54 FLOAT, HARVESTING. The 29th float in the parade, Harvesting represents Ceres, the goddess of grain and the harvest. She holds a horn of plenty as sheaves of wheat are gathered nearby from the fields. Native crops of pumpkins, grapes, and corn flow forth, which comprise a part of New York's large farm-based economy. (Redfield Brothers Inc.)

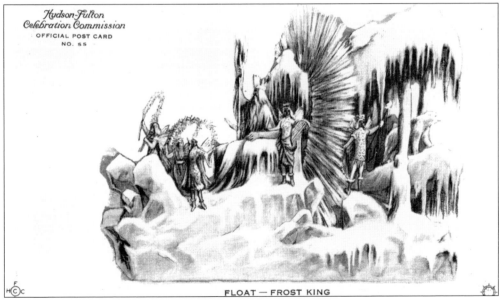

FLOAT — FROST KING

NO. 55 FLOAT, FROST KING. Representing a mythical figure that controls snow and ice, the Frost King directs fairies in charge of wind, snow, frost, and thaw. New York is infamous for winter weather with deep lake effect snows and a humid North Atlantic airflow across the Adirondack mountain region. Lake Placid was home to the 1932 and 1980 Winter Olympics. (Redfield Brothers Inc.)

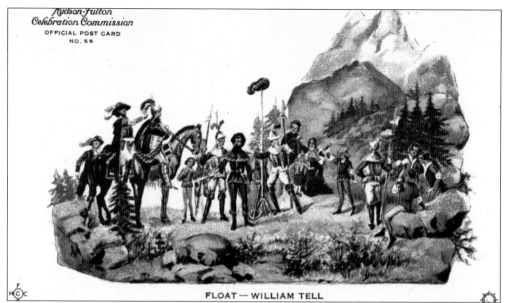

FLOAT — WILLIAM TELL

NO. 56 FLOAT, WILLIAM TELL. Floats for Humor and Origin of Poetry represented literature along with the writer Fritz Reuter and characters Nimrod and Andromeda. Float 24 of William Tell shows the famous marksman who shot an arrow from his son's head as ransom for his freedom, reversing condemnation to death. Following his feat, Tell seized the first opportunity to shoot the evil Gessler, the Austrian tyrant who punished Tell for not giving salute. (Redfield Brothers Inc.)

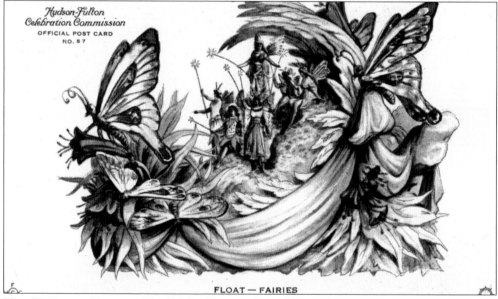

FLOAT — FAIRIES

NO. 57 FLOAT, FAIRIES. The Fairies Float, 45th in the parade, represented a home for these little people among the flowers and butterflies. Fairies slept all day and came out to play at night. On the same day as the carnival parade, New York City proclaimed a children's day. All public parks hosted pageants and festivals consisting of historical plays, folk dances, and music demonstrations. The carnival ended with an appropriate salute to the flag and singing of the "Star Spangled Banner." (Redfield Brothers Inc.)

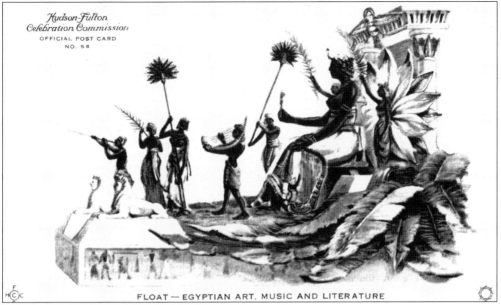

FLOAT — EGYPTIAN ART. MUSIC AND LITERATURE

NO. 58 FLOAT, EGYPTIAN ART, MUSIC, AND LITERATURE. Progress in ancient Egypt is represented by a central figure holding a godly, artistic statue, being serenaded by a musical harp and surrounded by literary hieroglyphics. Columns symbolize the great temples, and the Sphinx symbolizes mythical characters. Egyptology was extremely popular because of excavations in Karnack in 1903 that uncovered King Tut. (Redfield Brothers Inc.)

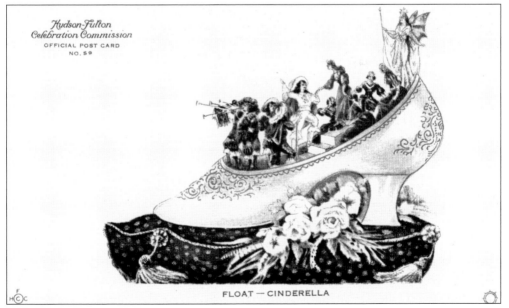

FLOAT — CINDERELLA

NO. 59 FLOAT, CINDERELLA. The prince in this float has just found that a silver slipper left at a ball fits no other woman perfectly in his kingdom except Cinderella. Surrounded by her wicked stepsisters, the character is seated in a huge slipper with the royal horn blowers saluting. (Redfield Brothers Inc.)

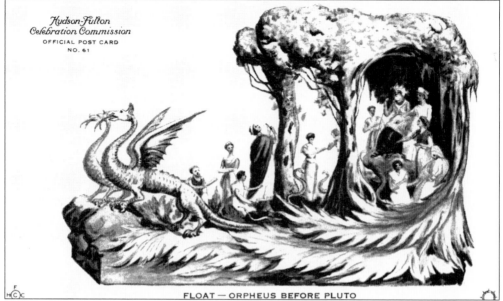

FLOAT — ORPHEUS BEFORE PLUTO

NO. 61 FLOAT, ORPHEUS BEFORE PLUTO. Orpheus, the son of Apollo, played the lyre so well that trees and rocks followed his music. His wife Eurydice was killed by a serpent, and Orpheus followed her to the regions of the dead, where he played sweetly for that region's king, Pluto. Eurydice was released to the land of the living to return with her husband. (Redfield Brothers Inc.)

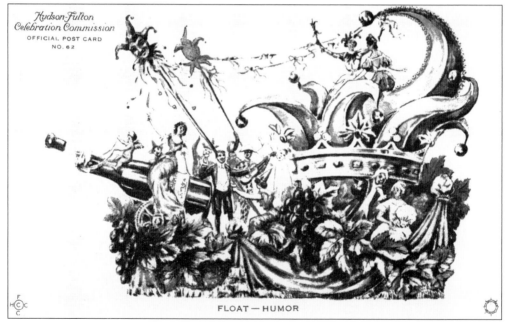

FLOAT — HUMOR

NO. 62 FLOAT, HUMOR. The jesters' wand and cap of folly accompany wine and grapes in dancing, singing, and humorous frivolities. Also on October 2, a memorial arch erected by the Daughters of the American Revolution was ceremoniously dedicated at the Stony Point Battlefield State Reservation at 12:15 p.m. with Gov. Charles Evans Hughes of New York in attendance and Frederick Seward of Abraham Lincoln's cabinet presiding. (Redfield Brothers Inc.)

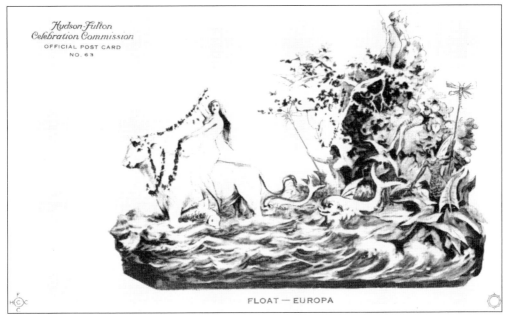

FLOAT — EUROPA

No. 63 Float, Europa. Europa was the daughter of the Phoenician king Agenor. The King of Gods, Jupiter, fell in love with Europa and transformed himself into a white bull joining a seaside herd near the girl. Europa noticed the gentle bull and crowned it with garlands. Climbing onto its back, the bull plunged into the sea and swam Europa to Crete where he returned to his kingly form. (Redfield Brothers Inc.)

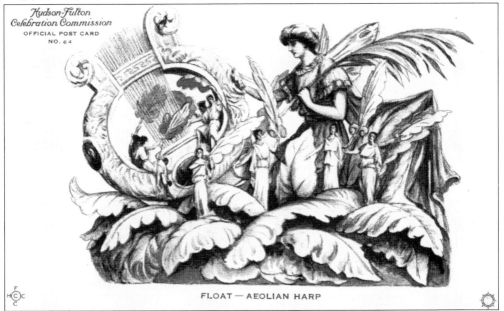

FLOAT — AEOLIAN HARP

No. 64 Float, Aeolian Harp. Idolizing the ancient musical instrument, figures representing wind play the harp strings with leaves and palm fronds. Sunday, October 3, 1909, saw a sacred concert in Carnegie Hall by the People's Choral Union and the instrumental New York Symphony Orchestra, under the leadership of Frank Damrosch. That orchestra was founded by the Damrosch family and later merged into the New York Philharmonic. (Redfield Brothers Inc.)

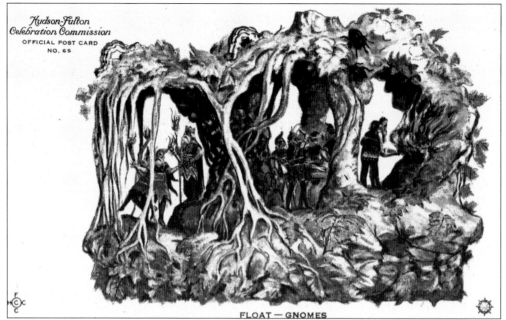

FLOAT — GNOMES

No. 65 Float, Gnomes. Living in a cave and blacksmithing by profession, gnomes play and work underground around the king gnome's court, spreading their mischievous ways. Gnomes have been popular garden decor since 1840. (Redfield Brothers Inc.)

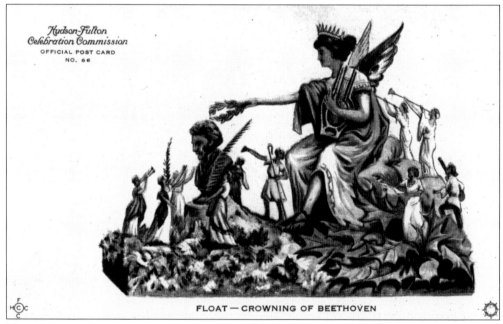

FLOAT — CROWNING OF BEETHOVEN

No. 66 Float, Crowning of Beethoven. Saluting the greatness of musicians, muses dance and sing as Beethoven is crowned. The United Singers of New York accompanied this float. Each of the boroughs as well as the country of Austria was represented in the parade by singing societies. (Redfield Brothers Inc.)

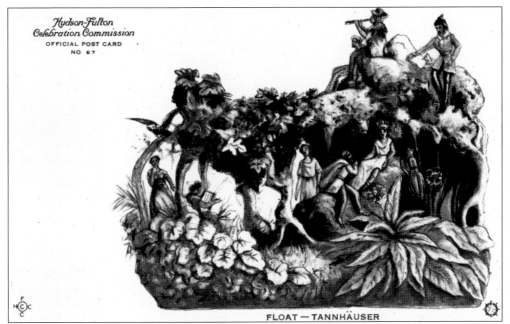

FLOAT — TANNHÄUSER

NO. 67 FLOAT, TANNHAUSER. The goddess of love, Venus, became bitter after being sent to earth and used sorcery to lure mortals to her cave. The great harpist Tannhauser was drawn to her cave and enraptured by her beauty and songs. Tannhauser was also a German poet from the mid-13th century. (Redfield Brothers Inc.)

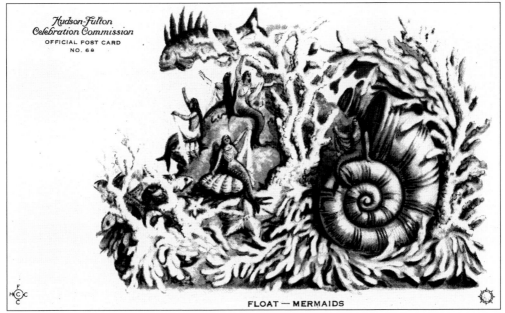

FLOAT — MERMAIDS

NO. 68 FLOAT, MERMAIDS. For ages, sailors' legends have described creatures with human bodies and tails of fish. Legends tell of these creatures luring men to the bottom of the sea with beauty and to destruction. Athletic men were represented in floats of the racer Marathon and the hunter Freishutz. Marching societies of bowlers, sharpshooters, and Turner athletes accompanied various floats. (Redfield Brothers Inc.)

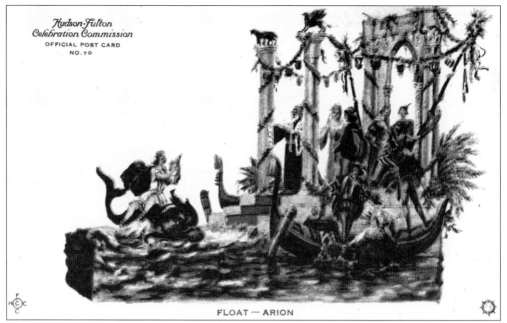

FLOAT — ARION

NO. 70 FLOAT, ARION. This famous Corinthian musician won great monetary prizes in Sicily. Upon return, Arion was captured by sailors who plotted to kill him. Through his song, Arion charmed the fishes and was saved by a dolphin that brought him safely home on his back to a fabulous reception. (Redfield Brothers Inc.)

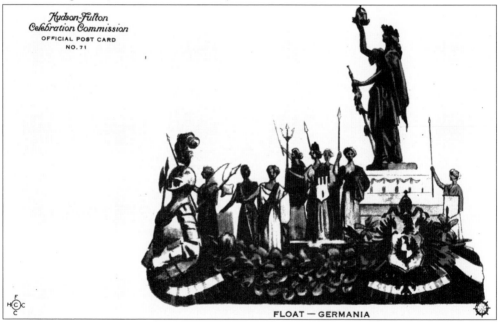

FLOAT — GERMANIA

NO. 71 FLOAT, GERMANIA. Representing an idealization of Germany, this float was centered by the crowned namesake surrounded by symbolic state eagles and colors of red and black. Nine figures represent the different states that comprised the United German Republic. The carnival parade concluded with floats of the Avalanche of Freedom and Uncle Sam Welcoming the Nations. (Redfield Brothers Inc.)

Six

UPSTATE

Night photograph of Getty Square, Yonkers, during Old Home Week and the Hudson-Fulton Celebration, October, 1909

Issued on June 22d, 1910, by *The Yonkers Electric Light and Power Company* in honor of the opening of the special public illumination of **Main** Street, between Getty Square and Warburton Avenue, by the *Main Street Business Men's Improvement Association*

GETTY SQUARE YONKERS. This night photograph of Yonkers at the corner of Warburton and Main Streets in Riverdale shows smaller town celebration festivities as these headed upriver. Yonkers was hailed as the lead city of Upper Hudson celebrations with parades on Monday, October 4, 1909. The city held an Old Home Week for the celebration with magnificent decorations by the Yonkers Electric Light and Power Company, which merged with ConEdison in 1951 to become one of the largest electrical suppliers. On October 9, Yonkers hosted an aquatic and sports day. (Yonkers Electric Light and Power Company.)

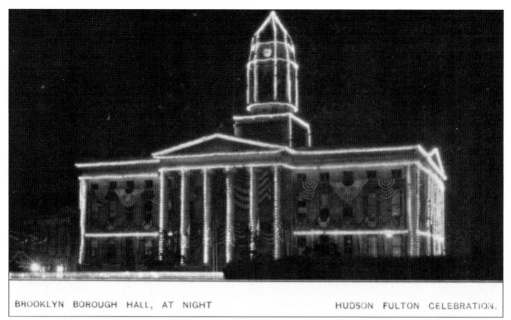

BROOKLYN BOROUGH HALL, AT NIGHT HUDSON FULTON CELEBRATION.

BROOKLYN BOROUGH HALL. Continuing from Manhattan, the celebration's illuminated glory may be witnessed in the neighboring boroughs of Queens and Brooklyn. This court building was completed in 1898. Brooklyn became a borough in 1898. On October 5, 1909, the celebration continued in Kingston, Hastings, Dobbs Ferry, Irvington, and Tarrytown. (The Universal Post Card Company.)

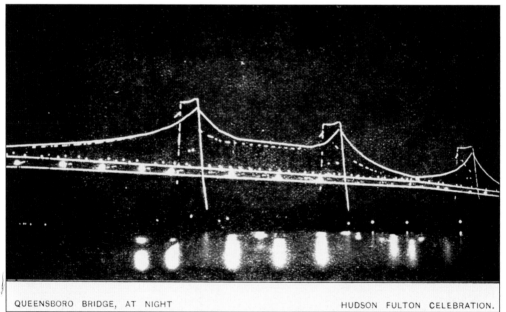

QUEENSBORO BRIDGE, AT NIGHT HUDSON FULTON CELEBRATION.

QUEENSBORO BRIDGE. The Queensboro Bridge is a double cantilever bridge that crosses the East River from New York City's 59th Street over Roosevelt Island to the neighborhood of Long Island City in Queens. Carrying roadway New York 25, the bridge was completed in 1909 after a long construction period due to its collapse in a windstorm. (The Universal Post Card Company.)

112

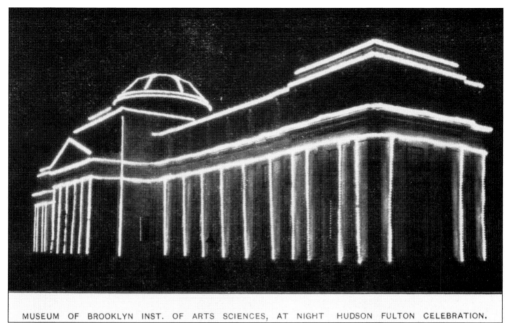

MUSEUM OF BROOKLYN INST. OF ARTS SCIENCES, AT NIGHT HUDSON FULTON CELEBRATION.

MUSEUM OF BROOKLYN INSTITUTE OF ARTS SCIENCES. On September 30 in Brooklyn, an international reception and ball was held at the Academy of Music for naval officers and diplomatic representatives. Also in Brooklyn, the Institute of Arts and Sciences hosted a self-portrait of Robert Fulton. (The Universal Post Card Company.)

VERPLANK'S POINT ON THE HUDSON. This landmark town across from Stony Point was the site of skirmishes and encampments during the Revolutionary War. Plans for a permanent exposition never transpired. On October 5, the Upper Hudson celebration continued at Catskill and Nyack. The following day was for Hudson, Ossining, and Haverstraw.

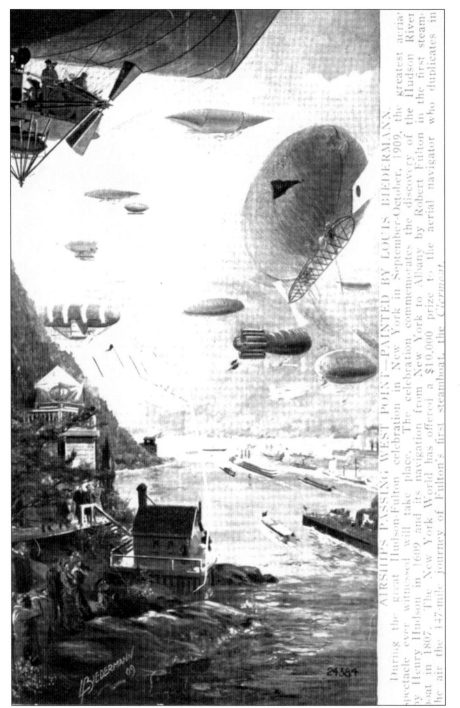

AIRSHIPS PASSING WEST POINT. A futuristic illustration was painted by newspaper artist Louis Biedermann for the celebration. Onlookers at West Point on the Hudson theoretically stopped to look at dozens of airships passing overhead. The card touts this "greatest aerial spectacle ever witnessed" offered from "The New York World $10,000 to the navigator who duplicates in air the 147-mile journey of Fulton's *Clermont*." (Louis Biedermann.)

PASSENGER FLEET PASSING WEST POINT. On Wednesday, September 29, a reception of official guests was held at the West Point Military Academy followed by lunch in the Memorial Hall, building inspections, and review of the cadet corps. (Barton and Spooner Company.)

THE HUDSON RIVER FROM THE BATTLE MONUMENT AT WEST POINT

THE HUDSON RIVER FROM THE BATTLE MONUMENT AT WEST POINT. Hudson was said to quote his namesake river as being "as fine a river as can be found." The view looking toward Newburgh from the famous battle monument at West Point is said to be the Hudson River's finest. (The Churchman Company.)

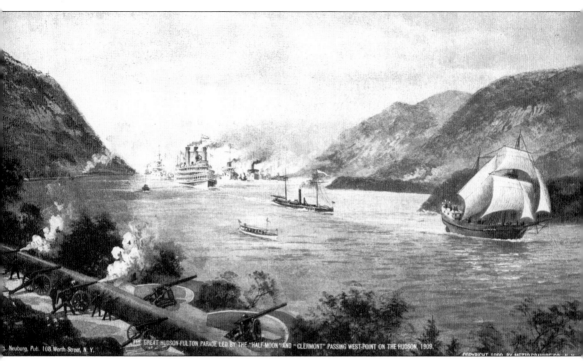

THE GREAT HUDSON-FULTON PARADE LED BY THE "HALF-MOON" AND "CLERMONT" PASSING WEST-POINT ON THE HUDSON, 1909.

THE GREAT PARADE PASSING WEST POINT (OVERSIZED). This oversized postcard is as large as three postcards at 10.5 by 6 inches tall. It proudly features "The Great Hudson-Fulton Parade led by the *Half Moon* and *Clermont* passing West Point on the Hudson, 1909." Army cadets fired ceremonial cannons shoreside as the flotilla passed on its way to Newburgh. Central to the scene is "the modern palatial SS *Robert Fulton* and the biggest of battleships and vessels ever assembled for similar purpose," according to the postcard's reverse. (Mezzo-Gravure Company.)

CORNWALL, N. Y.
HUDSON-FULTON CELEBRATION

PHOTO BY TALBOT
COPYRIGHTED 1909

CORNWALL AND THE BAY. This card contains an invitation to write away for information regarding hotels and boardinghouses to H. W. Chadeayne Esq., chairman of the hospitality committee in Cornwall. The reverse invites visits on Cornwall Day, October 1, for the finest view of the naval parade and best accommodations for "a fete which has never been equaled." (Talbot photograph, Cornwall Hudson-Fulton Committee.)

Come
Newburgh N.Y.
Hudson-Fulton Celebration Sept 25th to Oct 3-4 1909

COME TO NEWBURGH. A bucolic scene in orange hues invites visitors to Newburgh on the Hudson. The postcard's artist, Chatterton, was local to Newburgh. The beautiful, small town is represented with fashionable ladies strolling through a manicured park. The main festivities at Newburgh occurred on October 1, when the naval parade entered the town from both New York and Albany. George Washington used a home in Newburgh as headquarters in 1782 and 1783. Nearby is the campground of the American army in Revolutionary War. (Clarence A. Chattterton.)

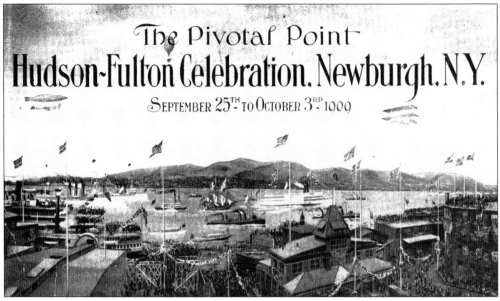

THE PIVOTAL POINT NEWBURGH. This advertising card sent by the Hillside Chemical Company of Newburgh contains a specific pill formula. The mixed treatment contains Hydrarg Biniodide in Potassium Iodide or mercury in salt. The mixture could be an external homeopathic remedy for ulcers. The prescription said to take one or two pills as directed three times a day after meals. Mercury is now known to be poisonous. The card offered samples and literature by writing to the company. (The New Company Newburgh.)

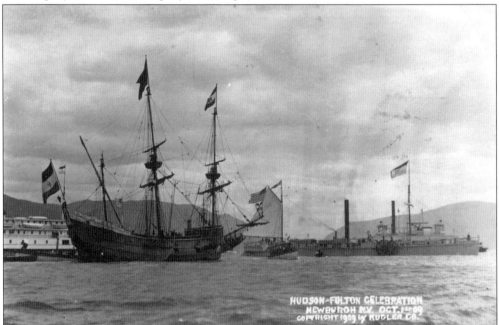

REAL PHOTOGRAPH OF NEWBURGH. On October 1, 1909, sailors and marines docked at Newburgh's south end and paraded to reviewing stands at the courthouse. A reception and luncheon for official guests and a complimentary shore dinner for 5,000 parade participants was held. Illuminations of the warships and fireworks punctuated the evening. (Cyko.)

Copyright 1905 by the Rotograph Co.

Reservoir, Mt. Beacon, N. Y.

Come to Fishkill-on-Hudson, N. Y., and go up to the top of the historic Fishkill Mountains.

BENJAMIN HAMMOND.

RESERVOIR MOUNT BEACON. A merchant, Benjamin Hammond, invited celebrants to visit Fishkill-on-Hudson across from Newburgh. Here the highest points along the Hudson may be found along with a reservoir that has since been dammed further. This card printed in Germany was used to advertise Hammond's Cattle Comfort spray sold by merchants and used to protect cows and horses. (The Rotograph Company and R. T. Van Tine.)

COURT OF HONOR POUGHKEEPSIE. On Sunday, October 3, Poughkeepsie celebrated with joint religious services highlighted that afternoon in Eastman Park with a 500-voice male chorus. The following day a great military, civic, industrial, and historical parade was held. A banquet and reception crowned the evening in honor of New York State's governor Charles Evans Hughes. The fleet left the next day, but Poughkeepsie devoted the entire week to reunions.

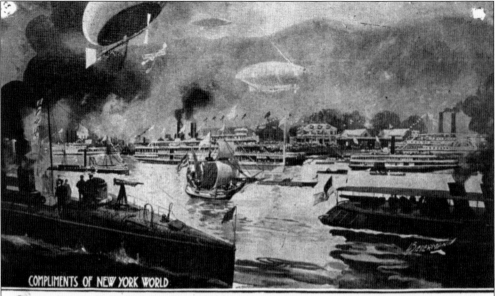

Greene County Day, Fulton-Hudson Celebration, Catskill, N. Y., Oct. 6th, 1909.

GREENE COUNTY DAY. This futuristic artistic rendering was compliments of the *New York World* and advertised the festivities in the town of Catskill, seat of Greene County. The naval parade arrived at 9:00 a.m. on Wednesday, October 6, and was received by an official committee and natives in canoes bearing gifts of corn. The men of the *Half Moon* were taken on a special expedition to Rip Van Winkle's Catskill Mountains. Gov. Charles Evans Hughes addressed the crowd. Fireworks and electrical illuminations capped the day. (Louis Biedermann.)

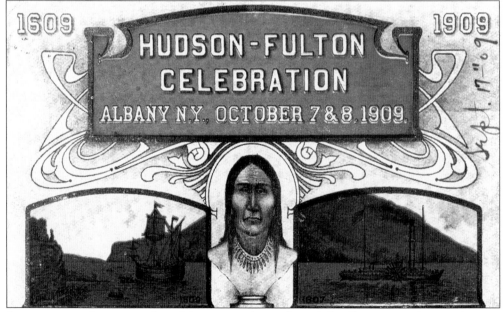

ADVERTISING ALBANY. The celebration with parade and flotilla continued in Hudson on Thursday, October 7 on its way to Albany. That same day, Albany was already celebrating with a children's festival, aquatic sports, and an automobile parade. That evening was fraternal night with special parade floats and marching uniformed ranks of various fraternal organizations.

Hudson-Fulton Celebration

October 7th and 8th, 1909. ALBANY, N. Y.

HUDSON LANDING AT THE SITE OF ALBANY IN 1609
DE HALVE MAENE (THE HALF MOON) AT ANCHOR

HUDSON

THE INTREPID EXPLORER
DISCOVERER OF THE
HUDSON RIVER
AND
FOUNDER OF ALBANY

HUDSON LANDING ALBANY. On its reverse, this card advertised law books from Matthew Bender and Company, which is now the legal division of the information giant Lexis Nexis. Seven law books, from Bender's *Penal Law* to Cook's *Criminal Code*, were offered for sale for $3.50 to $7.50. The card touts Hudson as the founder of Albany. (D. M. Kinnear.)

Compliments of

Amsdell Brewing Co.

Albany, N.Y.

AMSDELL BREWING COMPANY. This advertising card was postmarked on Albany's parade day, Friday, October 8. A mother to her son said, "wish you could have seen the Parade—it took nearly two hours to pass." The naval parade neared Riverside Park at 9:00 a.m. and proceeded with escort to the city. (Amsdell Brewing Company.)

121

The Capitol
Hudson-Fulton Day
Albany Oct 8 1909 204

ALBANY. The naval parade was saluted with guns, the ringing of church and fire bells, blowing of whistles, and band music. City officials then took carriages from city hall to the executive mansion where Gov. Charles Evans Hughes joined Albany's mayor Henry F. Snyder and proceeded to Riverside Park for welcoming speeches, accompanied by infantry troops. The capitol was built between 1867 and 1899 and cost $25 million. (Azo.)

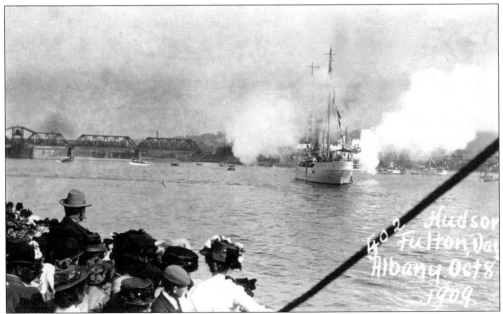

402 Hudson
Fulton Day
Albany Oct 8
1909

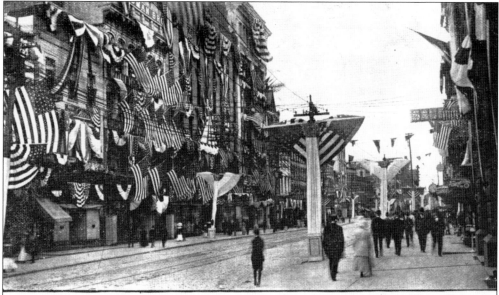

THE SHOPPING DISTRICT, NORTH PEARL STREET, ALBANY, N. Y.

Pub. by The Albany News Company

STREETS IN ALBANY. On October 8 at 1:00 p.m., Albany held the Hudson–Fulton welcome parade consisting of 23 of the historical floats connected to the Colonial period of New York. The parade featured 1,500 United States troops, an "All Nations Division" with floats from local societies representing foreign nations, and a "Business Men's Division." In this last division, prominent businesses participated, promoting the enterprise and civic pride of local merchants and manufacturers. (The Albany News Company.)

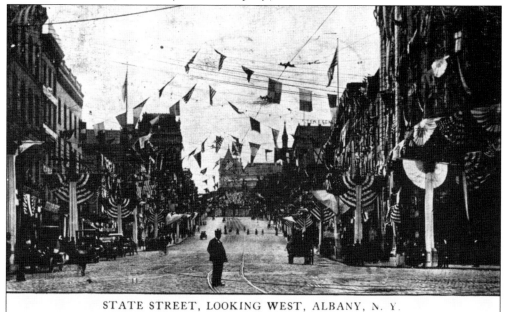

STATE STREET, LOOKING WEST, ALBANY, N. Y.

Pub. by The Albany News Company

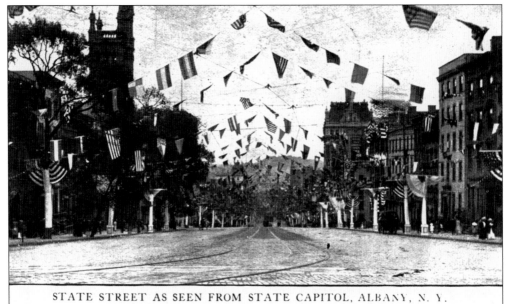

STATE STREET AS SEEN FROM STATE CAPITOL, ALBANY, N. Y.

Pub. by The Albany News Company

STATE STREET FROM CAPITAL ALBANY. Following the parade on October 8 at 8:00 p.m., fireworks were displayed at Beaver Park, now Lincoln Park, on the south edge of downtown at Morton Road. On the card's left, the high Gothic church is St. Peter's Protestant Episcopal at 107 State Street. That church was found in 1715 and granted Anglican charter by King George III in 1768. The church's present building is its third and was begun in 1868. (The Albany News Company.)

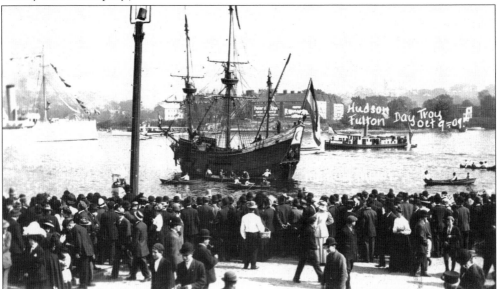

RIVERSIDE TROY. On October 9, 1909, at 8:00 a.m., the naval parade left Albany and travelled with the *Clermont* and *Half Moon* approximately 10 miles north to Troy. In Watervliet, two miles south of Troy, the parade was saluted by federal authorities at the United States Army arsenal. Troy, the seat of Rensselaer County, met the parade with a city flotilla of its own and proceeded to a land parade. (Azo.)

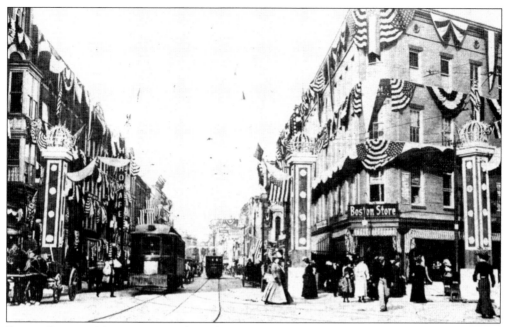

RIVER STREET TROY. On October 9 between 8:00 and 11:00 p.m., the celebration's second week and original plans came to an end with a chain of beacon fires on mountaintops and all along the river from Staten Island to the head of navigation. The fires were composed of peat and scientifically prepared to burn in any weather for the duration of this event. Along Troy's streets may be seen signs for the Boston Store and a hardware store.

Grand Court of Honor, Broadway and Third Street, Looking East.

GRAND COURT OF HONOR TROY. On October 9, the celebration reversed back to Cold Springs with a Putnam County water parade. Local participants joined in from Brewster, Carmel, Garrisons, Highland Falls, West Point, and other villages. The West Point Academy gave salute upon passing.

OLD DUTCH WINDMILL TROY. At Fourth and River Streets, this representative icon, a reminder from the early Dutch period, was decorated for the celebration. From Watervliet on October 9, the card's sender wrote, "This wheel looks fine at night when it revolves."

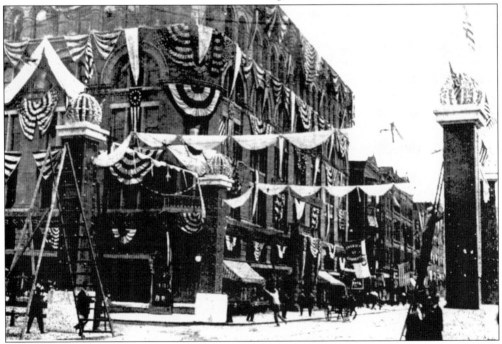

ILIUM BUILDING TROY. This handsome Beaux-Arts building is listed on the National Register of Historic Places and located at the northeast corner of Fulton and Fourth Streets. The building is presently occupied with businesses lining its street frontage. On the card's reverse, the sender wrote, "You ought to have been down last week. Troy was in her glory."

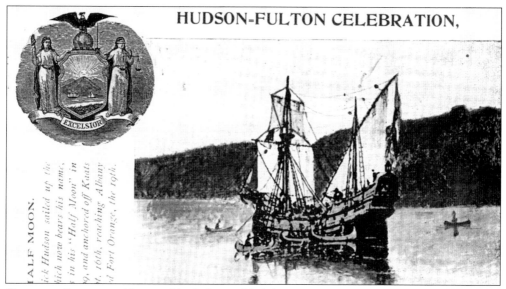

HALF MOON. ...ck Hudson sailed up the ...hich now bears his name, ...s in his "Half Moon" in ..., and anchored off Knats ...t. 16th, reaching Albany ...d Fort Orange, the 19th.

COHOES, OCTOBER 10 AND 11. Cohoes added festivities past the celebration's original end with church services on October 10. The following day, Cohoes welcomed the fleet from Troy and sent hundreds of motorboats as escort. A land parade and fireworks capped October 11 and concluded all celebration plans. This card was an advertisement from the Cohoes Savings Institution at Remsen and Seneca Streets. The reverse offered that "Money deposited on or before October 4th will draw interest at the rate of four percent per annum, payable January 1st." The card offers a commercial end to this historic event.

LAKE TEAR OF THE CLOUDS—SOURCE OF THE HUDSON RIVER

LAKE TEAR OF THE CLOUDS. The reverse states that "Few people contemplating the great Hudson River, and the mighty city in its mouth, know of the tiny Lake Tear of the Clouds, whence it sets out on its long journey to the sea. It is the highest body of water in the State from which water flows through a visible outlet." The lake is a tarn or mountain water formation pooled in an area excavated by a glacier. Theodore Roosevelt learned of Pres. William McKinley's shooting at the Buffalo Pan American Exposition while at the lake on September 14, 1901. (Seneca Ray Stoddard and the Churchman Company.)

ACROSS AMERICA, PEOPLE ARE DISCOVERING SOMETHING WONDERFUL. *THEIR HERITAGE.*

Arcadia Publishing is the leading local history publisher in the United States. With more than 3,000 titles in print and hundreds of new titles released every year, Arcadia has extensive specialized experience chronicling the history of communities and celebrating America's hidden stories, bringing to life the people, places, and events from the past. To discover the history of other communities across the nation, please visit:

www.arcadiapublishing.com

Customized search tools allow you to find regional history books about the town where you grew up, the cities where your friends and family live, the town where your parents met, or even that retirement spot you've been dreaming about.